15 MINUTE ART
DRAWING

JESSICA SMITH

Published in 2023 by Hardie Grant Books,
an imprint of Hardie Grant Publishing

Hardie Grant Books (London)
5th & 6th Floors
52–54 Southwark Street
London SE1 1UN

Hardie Grant Books (Melbourne)
Building 1, 658 Church Street
Richmond, Victoria 3121

hardiegrantbooks.com

British Library Cataloguing-in-Publication Data.
A catalogue record for this book is available from the British Library.

15-Minute Art Drawing
ISBN: 9781784885717

1 3 5 7 9 10 8 6 4 2
Publishing Director: Kajal Mistry
Acting Publishing Director: Emma Hopkin
Commissioning Editor: Kate Burkett
Senior Editor: Chelsea Edwards
Design and Art Direction: A+B Studio
Illustrations: Jessica Smith
Proofreader: Caroline West
Production Controller: Sabeena Atchia

Colour reproduction by p2d
Printed and bound in China by Leo Paper Products Ltd.

FSC
www.fsc.org

MIX
Paper from
responsible sources
FSC™ C020056

15 Minute Art

Drawing

JESSICA SMITH

Hardie Grant

BOOKS

THIS JOURNAL BELONGS TO

- -

THE PROJECTS

A little bit about *me...*

Hello, my name is Jessica Smith and I'm an illustrator and artist from the UK. Throughout my career, I've worked with some incredible clients on some amazing projects. I can't wait to teach you some tips and tricks on how to draw your favourite things. I create my artwork with a variety of materials, including gouache and digital processes, as well as marker pens and coloured pencils, which are the two media we will be using throughout this book.

I've always been a creative person, even when I was tiny, but it wasn't until my Art foundation year that I decided that I'd go to university to study illustration. To be honest, I didn't even really know what illustration was until this point. The next three years were spent at Falmouth University in Cornwall, in the UK, where I studied beside the sea. I think that's why I love drawing nature so much. I experimented with many different media during my time at university and I loved having the time to practise and try so many new things.

I've always loved the look and feel of marker pen and pencil illustration, but I was never sure how to incorporate that into my practice and make it work for me. In September 2021, I went to Cornwall for a week's holiday with my family and said to myself that I wanted to get better at drawing landscapes and places without using my usual medium of gouache. I took a pencil case stuffed full of marker pens and coloured pencils and a little Moleskine sketchbook. That week, I spent all my free time drawing, sketching and experimenting with this new way of working. I drew houses, little villages – in fact, everything I saw, I drew! I filled the sketchbook in no time and have been practising ever since. I'm so happy that I have the opportunity to share such an array of projects in this book to get you started with markers and pencils too!

Play was so important to me when I was developing my style and it's something that you never want to lose sight of. I hope that this book will be a place that you can practise, and play, too!

Tools and *materials*

Finding new materials that I love is one of my favourite things to do, but I know it can be rather overwhelming as there is so much choice out there. To save you a little bit of time, I've made a list of all the materials I love to use to create my drawings!

For marker pens I really recommend Tombow ABT Dual Tip Pens and Royal Talens Ecoline Brush Pens. These brands have the most amazing colour range and are so versatile. There are so many others on the market, though, so try a few and see which your favourites are. I like the Tombow ones because one end has a brush pen, while the other end has a finer tip which is perfect for adding details. The Ecoline range are a bit more watery, so they create a nice base for adding large areas of colour.

When it comes to coloured pencils, I am always drawn to those that have a creamy consistency and a vibrant colour. The two brands that I absolutely love are Caran d'Ache Luminance and Prismacolor Premiere. They layer over marker pens and gouache so well and are perfect for adding texture and details to finish off your illustrations.

Techniques – marker pens

Throughout this book, we will be using a range of techniques and I want to talk you through them here, so you can practise and become more comfortable with how to use them. There are so many ways to apply colour, which will help you create some lovely effects.

I'm going to show you how to lay down a base colour, create layers, add texture and blend colours. The two markers that I mentioned earlier, Tombow and Ecoline, are both water-based, meaning they can be blended with water and will act like a watercolour. This means you can achieve some beautiful blending effects.

BLENDING

To blend two colours, you can either use a paintbrush, a blender pen or just layer the two over one another. Start by laying down a section of one colour and then another colour next to it. You can see below that I'm using a green and mint together and a pink and pastel pink.

To mix the two pink colours, for example, I drew over some of the pastel pink with the darker pink. Try and do this quite quickly, so both inks are still a bit wet, as this helps them to blend more seamlessly. You can also use a paintbrush and water to do this, again by placing the two colours next to one another. Then take a wet paintbrush and run it down the centre to blend both colours together.

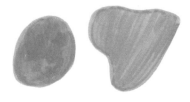

FLAT COLOUR

I love laying down a flat colour with marker pens as it creates a lovely texture and surface to draw on. The brush-pen quality means that it's super quick to colour a large area too, which is great when you're drawing on the go! For me, I've found that the best way to apply marker pens to a large area is to work from one side to another. This helps to keep the brushstrokes neat and ensure they don't overlap too much. However, if you want a messier and more textured base colour, you can draw in all directions and produce a colour that contains lots of different shades. You can see the differences between the two techniques above.

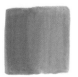

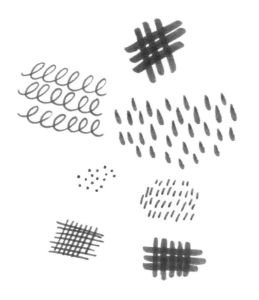

ADDING TEXTURE

Adding texture is a wonderful way to create pattern and interest in your illustration. There isn't one particular technique for this, but there are some ways that you can apply colour to get interesting marks. For instance, you can use the side of the pen for a more elongated mark or the tip for a fine dot. There are many ways you can experiment to create different textures, here are several options you could utilise in your artworks.

LAYERING

Layering marker pens is a great way to create depth and texture. Unlike gouache, you can still see the other colour beneath when you layer them, so it creates a whole new colour and is a helpful way to add shadow too! Using a cool-toned marker pen is my favourite way to add shadow to an illustration – as you will see throughout the projects in the book. Markers have a low opacity, and you can get some lovely effects, as seen in the swatches on the right.

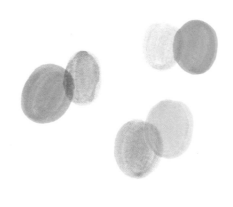

Top Tip: When layering markers, it's best to start with the lightest colour. This is because the low opacity makes it hard to see light colours over the darker colours.

PRESSURE

Brush pens are sensitive to pressure, so you can get some nice line quality in an instant! For a thicker line, you need to press harder and for a thinner line, apply less pressure. You can see to the left how this looks when you put pen to paper.

Techniques – coloured pencils

Coloured pencils are such an amazing way to add texture and details to your illustrations. The two that I will be using in this book are Caran d'Ache Luminance and Prismacolor Premiere. These are more premium pencils. There are many more affordable ones, but these layer over other materials so nicely and have such amazing colours.

SHADING

Shading with coloured pencils is a great way to add depth and dimension to an illustration. By applying different levels of pressure, you can achieve lighter or darker tones to add shadows to objects. A light pressure will give you a light colour and a harder pressure will give you a darker, richer colour. A good tip when shading is to hold the pencil sideways, so that the largest surface area is touching the page. This allows for the smoothest application of colour and will help you avoid any harsh lines. To get a darker shade, use the tip of your pencil. The tip is great for achieving sharper and more precise lines; just make sure you are confident about your lines, as they will come out darker than when you use the side of the pencil. You can see on the left how the different applications look on paper. Have a little practice to familiarise yourself with how to hold the pencil!

CROSS-HATCHING

Cross-hatching is another way to add depth and shading to your illustrations, but with a little more texture and pattern. It involves crossing over lots of lines to make a grid with varying distances between the lines to create darker or lighter shades. Lines that are closer together will make a darker shade and lines that are further apart will create lighter shades. You can see the differences between them and how you can use them to shade objects on the right.

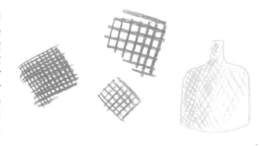

LAYERING

You can also layer coloured pencils to add depth or alter the colour of the base. For example, if you had a pink base layer, you could layer a red lightly on top to make the pink appear slightly darker. You could also try applying a cooler colour such as a blue to add shadow too. The coloured pencils that I have recommended here layer over one another really well due to their high opacity and vibrant colour, but remember, always work from light to dark so they look their best over one another.

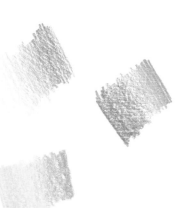

BLENDING

To blend two colours, take the first colour and begin with a small section using quite a hard pressure. Then moving to the right, start to lighten the pressure until the colour almost isn't there. Then repeat with the next section of colour, this time working from the other side into the middle, until this colour overlaps the first. You can alternate with the other colour to help blend the two together.

You can see above how to do this.

14

Colour
story

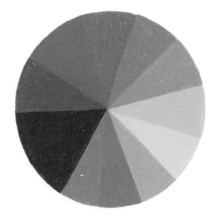

Choosing colours is a really important part of creating artwork and a knowledge of colour theory can help you make the right decisions and find colours that sit together nicely and complement each other. Colour theory can help you understand colour combinations, the properties of colours themselves, and how we perceive the different elements of an artwork.

PRIMARY COLOURS

The colour wheel shows the relationship between colours. The basic colour relationships are between primary, secondary and tertiary colours. The three primary colours are red, blue and yellow. They are known as primary colours because you use them to create all other colours (and they themselves cannot be mixed from other colours)!

SECONDARY COLOURS

If you mix two primary colours, you will get a secondary colour – for example, red + blue = purple. Similarly, yellow and red produces orange, while blue and yellow creates green. Look at the swatches on the right to see how the secondary colours are created.

TERTIARY COLOURS

The final group of colours are called tertiary colours and these are created by mixing equal parts of a primary colour and a secondary colour. For example, to create yellow-green, you would mix equal parts yellow (primary colour) and green (secondary colour). You can see on the right that I have created some swatches to show you the selection of tertiary colours and how you could use them with other colours!

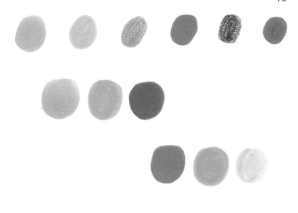

COMPLEMENTARY COLOURS AND COLOUR PALETTES

I like using the colour wheel for colour selection, as it really helps me choose colours for my illustrations. Complementary colours are colours that sit opposite each other on the colour wheel. Red and green, yellow and purple, blue and orange are the three main pairs, and they all work so well in illustration and design. Once you've got the hang of how colours work together, you can be more creative. For example, I love using red and blue together, but will often add a light pink or peachy colour too. To the right are some examples of colour palettes that I love!

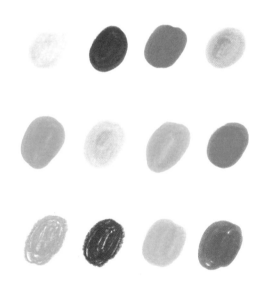

I've included a few of my favourite illustrations here, so you can see how complementary colours can work in artworks.

Sketching

Sketching your drawing out prior to adding colour is a great way of making sure you get everything in the right place. It will make you feel much more confident when it comes to picking up your pens and pencils later. My top tip for sketching is to use a coloured pencil instead of a lead one because you won't be able to see it as obviously through the pens or pencils. I find lead pencils quite harsh and don't always like how they look when left on a drawing at the end. My favourite pencil for sketching is the Lyra Rembrandt Polycolour in medium flesh. It's what I've used throughout the book, so you can see how it looks after adding colour!

However, if you're not feeling too confident with sketching out your own design, I've included templates for every project in the book! You can grab a piece of tracing paper and use them to get practising. If you are feeling up to the challenge, then go ahead and sketch out your design for the project. You can also put your own twist on the design if you've got something in mind.

Before you start sketching out your design, make sure you've had a good look at a reference photo or the object that you are drawing. I often find myself staring at a blank page when I get a bit stuck and then end up drawing nothing, so make sure you don't do this too! Study the thing you are drawing and let your pencil make light shapes on the page. You can then go over them with a slightly darker line that is more final.

Project 01

Strawberry plant

Strawberries are the ultimate fruity summer treat. If you can hold off eating them for long enough to draw them, you've done very well!

STEP 01

Sketch out the strawberry plant with its droopy stems and lovely fruit. Or trace the template on page 228.

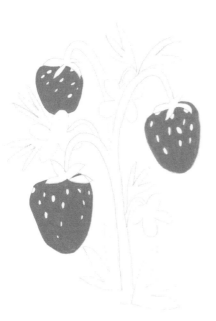

STEP 02

First we're going to block in the colour of the strawberries. Make sure you leave some negative space for the strawberry seeds on the outside.

I used a marker pen here, as I love how easy it is to apply and the smooth texture it gives to the surface.

STEP 03

Now colour in the stems and leaves in two different shades of green. Use a bright, light green marker pen for the stems and a darker green for the leaves. This helps to differentiate between them when you start adding the details.

You can also colour the tops of the strawberries in the same dark green as the leaves. Next, add several little yellow dots to the centres of the flowers.

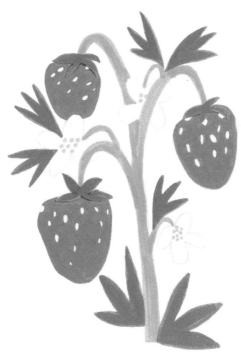

STEP 04

Next add the shadows. Using a cool-toned blue marker pen, you need to add small shadows to areas that are behind other things or overlapping. You can see on the white flower at the top where I have added a blue line. Do this all over the drawing to help bring it to life.

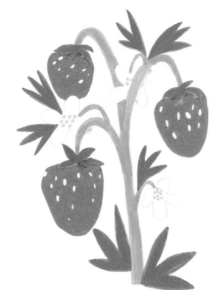

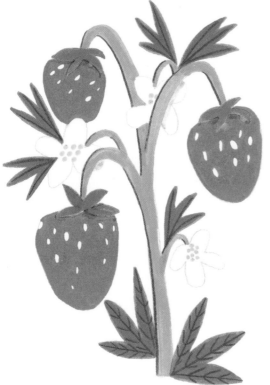

STEP 05

Lastly, add the veins to the leaves and some little areas of shadow to the stems.

Project 02

Citrus

Here we are drawing some citrus fruit, namely a lemon and an orange. You could add lots of these to a tree or perhaps arrange them in a fruit bowl on a table.

STEP 01

Sketch out a very simple orange and lemon; just focus on the round shapes of the fruit and the leaves here. Add some leaves to the top of the orange to provide some contrast when it comes to adding colour. Alternatively, trace the template on page 229.

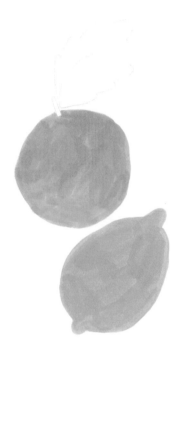

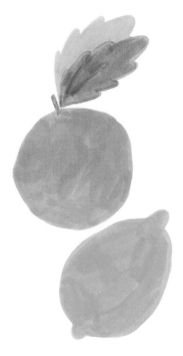

STEP 02

Next, blend yellow and orange marker pens together for the orange which is such a nice effect when illustrating something that could look quite flat. You can find some tips on how to blend on page 13. I left the lemon as a block colour, so you can see the difference between the two effects.

STEP 03

Now add the leaves to the orange, using two different shades of green to show that one leaf is behind the other. Add the stalk using a brown marker pen too.

STEP 04

Adding some shadow to the orange is next. Using a cool-toned marker pen add any shadow that might be there, whether that is from the stalk or just where the light isn't hitting the surface of the orange. I used a blue pen here to add the shadow and I love how you can still see the colour of the orange through it.

STEP 05

Add further details using coloured pencil. I added some texture to both the orange and lemon using a colour similar to the base layers, as I didn't want them to be too obvious. I did the same on the leaves and added some dots to each fruit, just to give it a little more texture too.

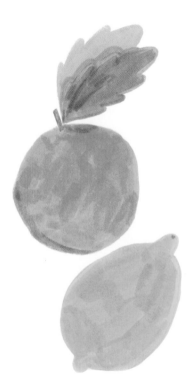

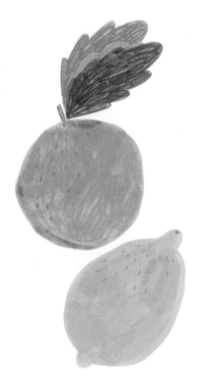

Project 03

Daisy

For this project we're going to draw a wiggly daisy! I've chosen this flower because the petals are really nice to draw and you can mix up the colours if you like.

STEP 01

Begin by drawing the basic shape of the daisy or trace from the template on page 228.

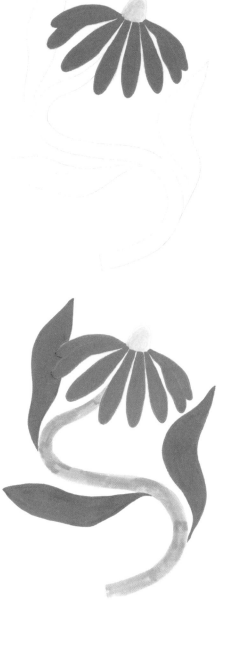

STEP 02

Now, we're going to colour in the flower of the daisy. You could use two colours that are similar here or colours that contrast strongly with each other. I decided to use two different shades of pink marker pen, so the flower would really stand out against the green stem.

STEP 03

Now add the colour for the stem and leaves. I chose mint-green and bright green marker pens for these, and I love how these colours really complement the pink of the daisy.

Top Tip: To get a really nice fine line with the Tom Bow markers, it is best to use a really light pressure and the very tip of the pen.

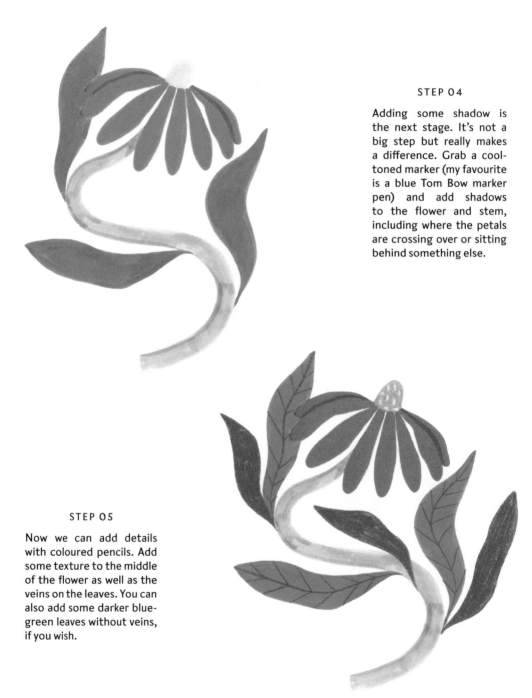

STEP 04

Adding some shadow is the next stage. It's not a big step but really makes a difference. Grab a cool-toned marker (my favourite is a blue Tom Bow marker pen) and add shadows to the flower and stem, including where the petals are crossing over or sitting behind something else.

STEP 05

Now we can add details with coloured pencils. Add some texture to the middle of the flower as well as the veins on the leaves. You can also add some darker blue-green leaves without veins, if you wish.

Project 04

Tulip

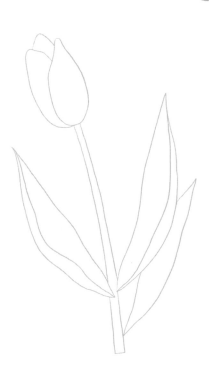

Tulips are such elegant flowers and they come in so many gorgeous varieties. Why not draw one that will never wilt?

STEP 01

Sketch out the tulip or trace the template on page 229 – you can add multiple tulips if you like!

Top Tip: When sketching, I like to use a light-coloured pencil instead of a graphite lead pencil, just because it is less obvious when you colour your piece in and you can't see the lines as much through the marker pens.

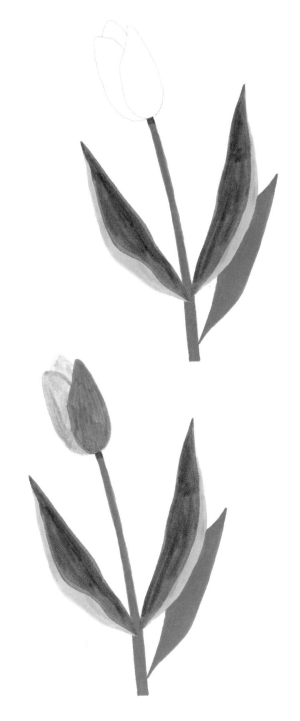

STEP 02

Start by colouring in the stem and leaves. Choose a few shades of green marker pen here to emphasise that they are separate and so they don't all blend in together. I chose two shades for the leaves and a different one for the stem. I also added a little dark area just beneath the flower head to indicate some shadow.

STEP 03

Next, colour in the head of the tulip. I chose purple marker pens for this one in three different shades, one for each of the petals. Start with the light colour at the back and use the darkest colour at the front. It's important to do it this way because the dark will go over the light much more easily than the light over the dark.

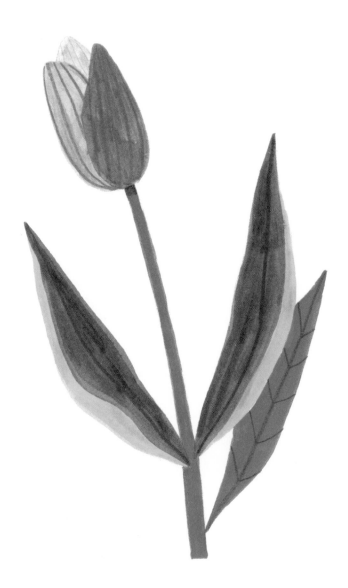

STEP 04

Finally, add some veins to the leaves with a dark green coloured pencil. Add these touches to the tulip flower as well using a purple pencil.

Project 05

Bunch of flowers

Flowers are one of my favourite things to draw, so I knew I had to include a bunch of them in my book!

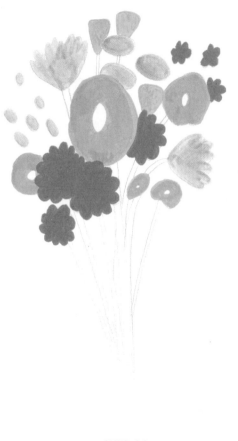

STEP 02

I chose to use a limited colour palette to make the flowers really pop against the green stems. You can, of course, choose whatever colours you like, but I opted for pink, lilac and red. Simply block colour all the flowers at this stage – I used marker pens here as I love how quickly you can cover an area and the fun texture they give the flowers!

Top Tip: Use different colours next to each other to really make them stand out.

STEP 01

First, sketch out a rough outline for the bunch of flowers. If you find it easier to draw from life rather than making up the design yourself, feel free to use a reference image to help you. Alternatively, trace the template on page 229!

STEP 03

It's shadow time! Start by grabbing a cool-toned marker pen or pencil (I like the opacity of markers).

Have a look and see where things are overlapping, such as flowers in front of other flowers. Then add a shadow to anything in the background that is being overlapped by something else.

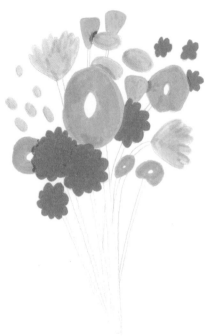

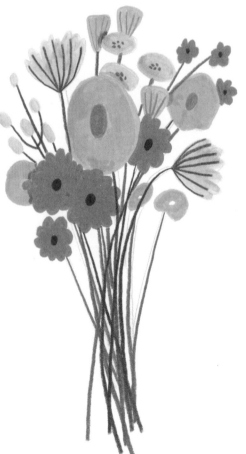

STEP 04

Now it's time to add some details and greenery. I decided to use coloured pencils here because I love the contrast of textures between marker pens and pencils, and I think they sit so well over one another.

I chose three tones of green for the stems to ensure there was some variation, but not so much that it takes away from the blooms at the top. Make sure you've got a really sharp pencil to get a lovely, thin, precise line for these.

Now add any details you'd like to the flowers. I added centres to the flowers and a couple of lines and dots for texture.

Project 06

Seaweed and coral

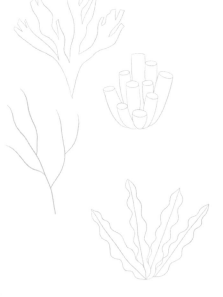

Both seaweed and coral
come in an astounding
array of colours, shapes
and textures, which
make this project a joy!

STEP 01

Start by sketching out some varieties
of seaweed and coral. Some of my
favourites include spiral wrack, dulse
and common coral weed. If you wish,
trace the template on page 228.

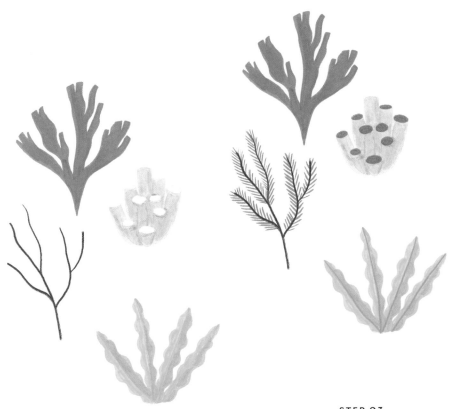

STEP 02

Make your selection of colours for each piece of seaweed or coral and block in the main body. As you can see with the two-toned pink seaweed, I used two different shades of pink marker pen, so I could have red and blue on top as a contrast.

For the aqua-green seaweed, I also used a marker pen because I wanted to get a sense of movement in the blades and I think pens work better for this effect.

STEP 03

Now we can add some of the little details. I think this is what really makes the coral and seaweed come to life!

For the coral, I used a magenta-coloured pencil, as I wanted a lovely bold colour for the insides of the tubes.

For the spiky-looking seaweed, I used an aqua-green marker pen to add the little swishy leaves. Using a really light pressure, you can achieve a flowing line which works really nicely for fronds such as this.

For the two-toned pink seaweed, I added a red stripe using coloured pencil down the middle of each blade.

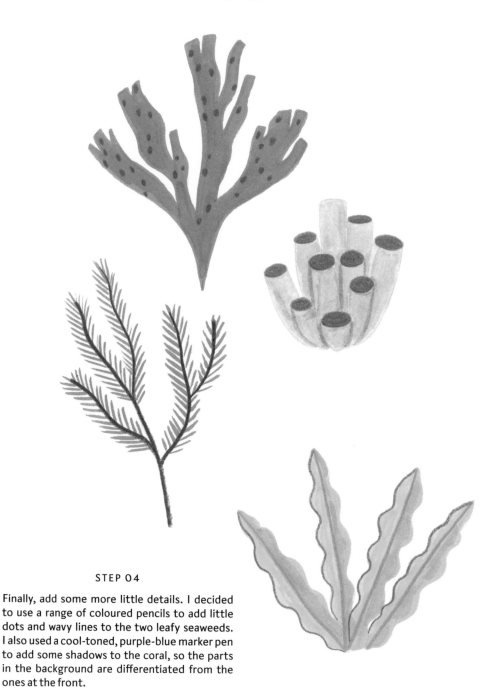

STEP 04

Finally, add some more little details. I decided
to use a range of coloured pencils to add little
dots and wavy lines to the two leafy seaweeds.
I also used a cool-toned, purple-blue marker pen
to add some shadows to the coral, so the parts
in the background are differentiated from the
ones at the front.

Project 07

Cactus

There's nothing cuter than a little plant in a pot, so that's why I decided to include a potted cactus as one of my projects.

STEP 01

Sketch a rounded mound shape to create a very simple cactus and pot. If you'd prefer to trace the template, head to page 228.

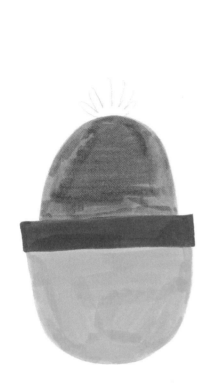

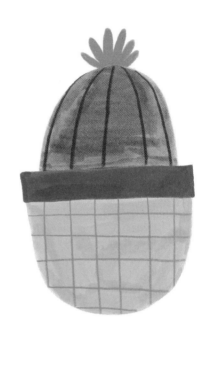

STEP 02

Use marker pens to colour in the pot and the cactus, leaving the little flower blank for now. You can choose whatever colours you like, but I decided on a pink and a dark ultramarine blue for the pot to go with the greenish-brown cactus as they contrast strongly with each another.

I really love the texture from marker pens when you scribble with them – it makes me feel as if I am colouring in like a child again!

STEP 03

Now for the details. For the pot, I added a simple grid pattern by using a bright red coloured pencil over the pink. Red and pink look so fun when used together and are a favourite combination of mine. Using the same red, I also coloured in the flower on top of the cactus. I decided to do this in coloured pencil too because I wanted it to be super bright. I also added some dark green lines to the cactus to give it some shape.

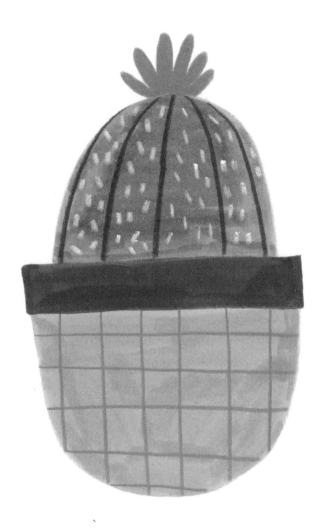

STEP 04

Finally, add some lighter details, using a white coloured pencil for the spikes on the cactus. I really love how the white looks over the dark colour and it is perfect for adding highlights too.

Project 08

Shell

There are so many possibilities with this project, as there is an abundance of beautiful shells you can draw. We're doing a simple one here for practice, but you could then move on and draw lots of different ones too!

STEP 01

The first step is to sketch out a very simple snail-shell shape. If you wish, trace the template on page 229 instead. I chose this spiral-shaped shell because I love how it looks when all the lines are added.

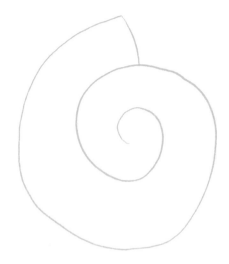

STEP 02

Block colour the shell in mint-green marker pen. While the ink is still slightly wet, add a darker aqua colour where the swirls meet each other and then go back over with the lighter colour. This will blend the colours together and make them look more seamless.

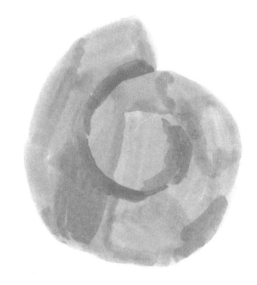

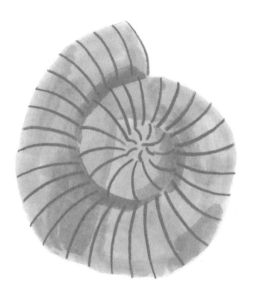

STEP 03

Now add the lines, which really give the shell some dimension and stop it looking completely flat. I used a dark turquoise coloured pencil here for a nice sharp line. When you add the lines, make sure they have a slight curve, so your shell looks rounded.

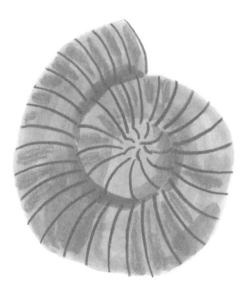

STEP 04

Finally, to add some more texture to the surface of the shell, use a light blue coloured pencil and colour in some little areas between the lines. You can use a similar colour to the base colour for the shell or a contrasting one.

Project 09

Window

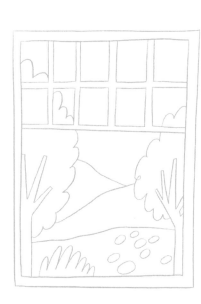

This is a fun way to get into drawing landscapes – take inspiration from whatever you can see through your window!

STEP 01

Begin by drawing the window frame and then the elements you can see inside it. Alternatively, you can trace the template on page 230.

STEP 02

Choose three shades of green marker pen for the grassy areas. Colour the most distant area first with the lightest green marker, working your way forward to the darkest green in the foreground.

Leave negative space for the flowers and bush as these will be filled with colour later.

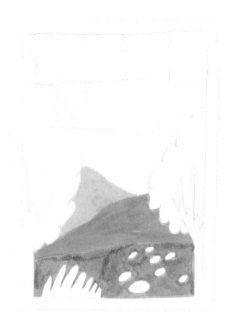

STEP 03

Using two different green coloured pencils, scribble in the tops of the trees (staying inside the lines!) – this effect is great for anything leafy as it creates a nice texture.

You can also add the stems of the flowers at this stage using a dark green coloured pencil.

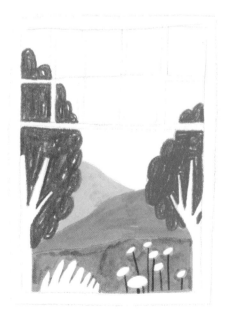

STEP 04

Next add the trunks of the trees, using a very dark brown and then the pink for the flowers. I chose pink because it stands out so well against the green. Then add some little grass details to the middle area using a green pencil that is darker than the base layer of green.

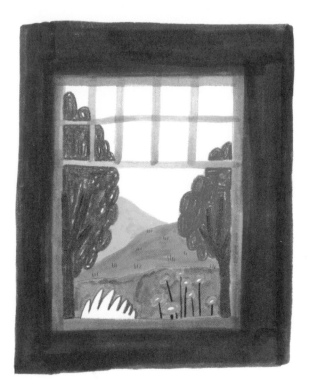

STEP 05

Finally, add the window frame you are looking through. I chose a very dark blue here to give the impression that the inside of the room is much darker than outside.

I also decided to use marker pens for the frame because I love the way they look against the details of the landscape. They are a great way to cover a large area in a short amount of time too!

Project 10

Mushrooms

Mushrooms are such
fun things to draw
with their wiggly stems
and brightly coloured
caps. Here's a colourful
selection for you to draw.

STEP 01

Sketch out the basic shapes of some mushrooms,
focusing on the stems and semi-circular caps.
You can always trace the templates on page 231,
if you wish. Try and get a nice variety of shapes
here: tall, short, fuzzy and lumpy!

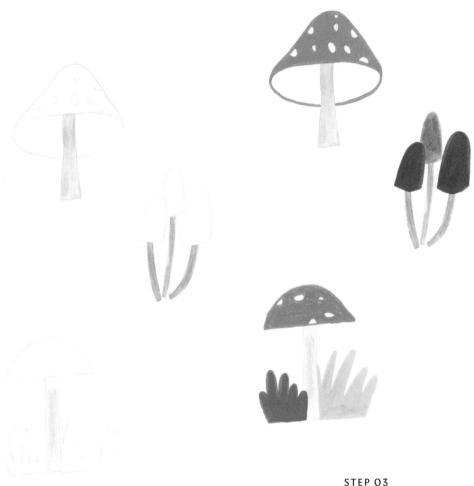

STEP 02

Begin by colouring in the mushroom stalks. I chose a host of different colours for mine, as I wanted to make them bright and fun!

STEP 03

Now add some super-vibrant colour! You can use whatever colours you like, but I kept to three colours or fewer per mushroom. This helps them look more considered and put together. I also decided to use complementary colours for each one (see page 15). For the tops of the mushrooms, I used a mixture of marker pens for the magenta and blue ones and coloured pencil for the red one.

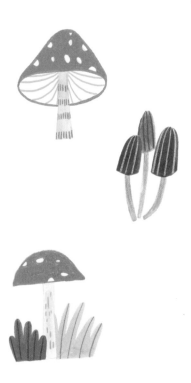

STEP 04

Next add some details to the stalks and the tops of the mushrooms. I chose a yellow pencil to add the gills on the underside of the magenta mushroom because the colours contrast really well. I also added some little lines to the stalk to give it some texture.

For the blue mushrooms, I decided to use a white pencil on top of a dark marker pen. I love the effect this gives, as it looks as if the sunlight is shining on the tops.

I kept the classic red mushroom quite simple with some fun foliage, using green and yellow marker pens, and a few pink lines on the stalk like the magenta one. I added some lines to the greenery with a darker green pencil.

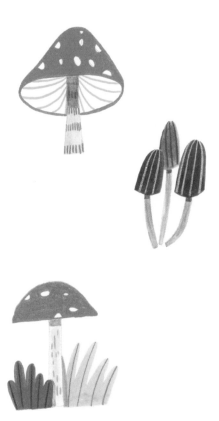

STEP 05

Finally, add some shadows, as this always finishes off a drawing. Take a cool-toned blue marker pen and add a small shadow to the stalks below the top of the mushroom caps. This shows where the shadows would be cast. If you've included greenery with the red mushroom, you can also add some shadow to the bottom parts of the stalk sitting behind the foliage.

Project 11

Leaves

This simple project is
nice and speedy, and
uses only three steps!
Here we look at a few
ways to illustrate leaves
as well as the colours,
shapes and textures
you can add to them.

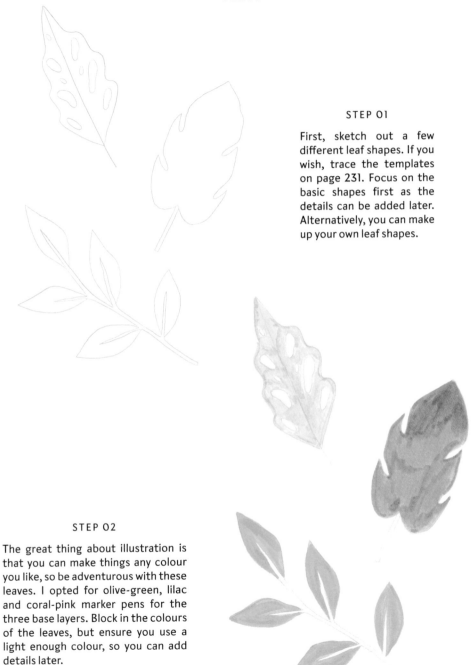

STEP 01

First, sketch out a few different leaf shapes. If you wish, trace the templates on page 231. Focus on the basic shapes first as the details can be added later. Alternatively, you can make up your own leaf shapes.

STEP 02

The great thing about illustration is that you can make things any colour you like, so be adventurous with these leaves. I opted for olive-green, lilac and coral-pink marker pens for the three base layers. Block in the colours of the leaves, but ensure you use a light enough colour, so you can add details later.

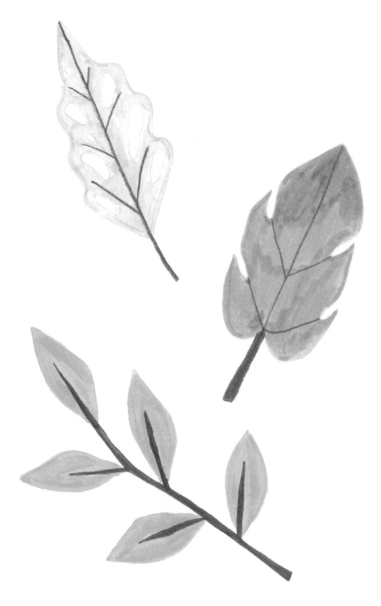

STEP 03

Finally, add in the details to the leaves. Here I used deep magenta and dark teal coloured pencils for the stalks and veins of the leaves. You might also want to add some extra colours to the base layers with coloured pencil, as this gives a great texture to the finished piece.

Project 12

Still life 1

I love drawing contemporary still-life pieces. They're a great way to play around with composition and colour.

STEP 01

When sketching the still life, aim for an odd number of objects – three or five work best – as this will make the final composition look balanced and considered.

I chose a vase, some fruit and a pot of pencils. Either copy this composition or create your own. I included a variety of soft and more angular shapes to give the finished piece a nice balanced feeling. If you wish, you can just trace the template on page 230.

STEP 02

Colour in the background and the table first, leaving all the objects as negative space.

I used a marker pen in vibrant blue for the background and pinkish lilac for the table. Marker pens are ideal because you can cover a large area quickly.

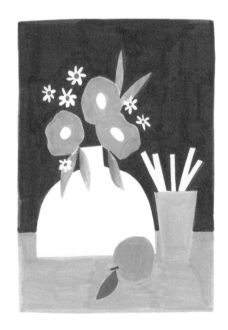

STEP 03

Now colour in the smaller areas: the flowers, orange, the pot for the pencils, and all the leaves. Again, I used marker pens here, as I wanted to add all the details with coloured pencil. When picking your colours for these areas, make sure they contrast well with the background colour.

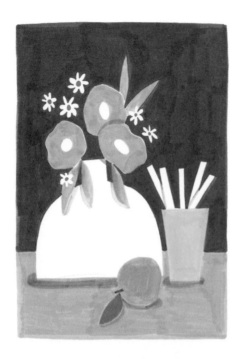

STEP 04

Next, add all the shadows. Take a cool-toned marker pen or pencil in either blue or purple and shade in where things are overlapping or sitting behind each other.

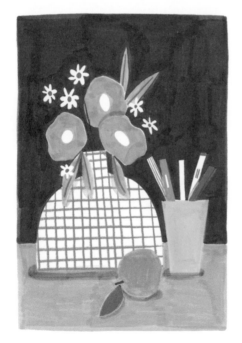

STEP 05

Now, we're going to pop in all the nice little details. I always think the details make a piece, so this is often my favourite stage!

Using a green that is a few shades darker than the leaf colours, add some veins to the leaves and maybe colour in one of the pencils too. Then, using a colour that contrasts well with the two background colours, add a fun pattern to the vase. I opted for a chequered pattern here, as I love the way this looks with the organic shapes of the flowers and leaves.

Finally, add some stems for the little flowers and colour in some of the remaining pencils!

Project 13

Still life 2

Here's another still-life scene featuring flowers and fruit as the subject, but this time round, I've included some differently shaped vessels.

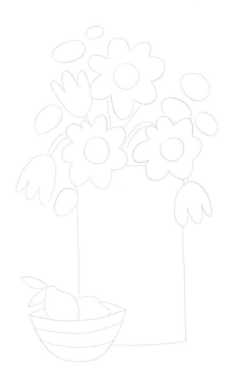

STEP 01

As for the first still life, you want to carefully choose the objects you want to include carefully. Play with scale and shapes and include some pieces in the foreground to help give the piece some depth. Sketch out the design or feel free to trace the template on page 230.

STEP 02

Begin by colouring in the vase and fruit bowl. I chose a pink and some shades of blue here, as these colours sit really well next to each other. Choose three shades for the bowl: two for the pattern on the outside and then a lighter shade for the inside.

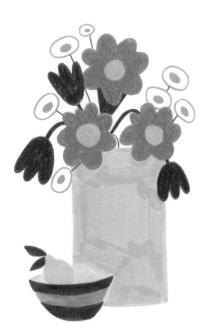

STEP 03

Next, add all the areas that use coloured pencil. I decided to use coloured pencil this time for all the flowers, so you can see how nice the texture looks when coloured in blocks. I also coloured in the leaves of the lemon with a lovely dark green, which I also used for the stems of the flowers.

Top Tip: Make sure you've got a pencil sharpener handy when colouring in large areas, as the pencils can get blunt quite quickly!

STEP 04

Lastly, add some shadows. Here I've shown you how it looks when you add shadow underneath the drawing, to give the illusion that it is sitting on a surface. I also added shadows to the vase, under the flowers and behind the bowl.

I used a cool blue marker pen for the shadows, but you can use a lilac or maybe a blue coloured pencil instead.

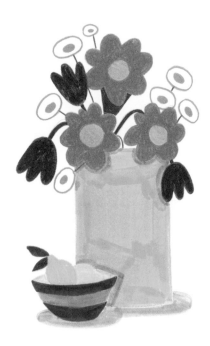

Project 14

Table lamp

I've chosen this object because you can add some really fun patterns to the lampshade and be creative with the shape of the lamp base.

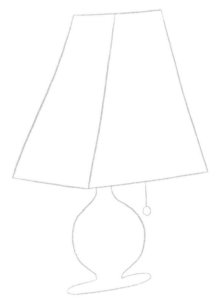

STEP 01

Sketch out the lamp or trace the template on page 231. If you are sketching the design yourself, break it down into the basic shapes.

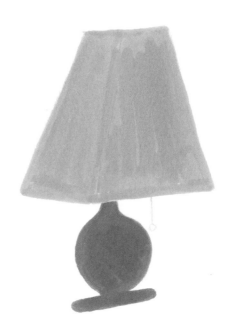

STEP 02

Colour in the base of the lamp and the lampshade. Pink and green have been used here because they are contrasting colours and sit really well next to each other. I used marker pens for these areas.

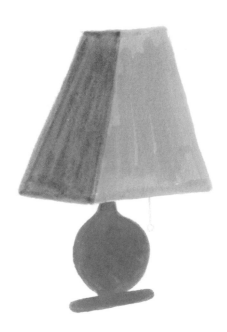

STEP 03

Next, add some shadow to the side of the lamp. To do this, take a light blue marker pen and colour over the pink on the left-hand side of the lampshade.

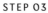

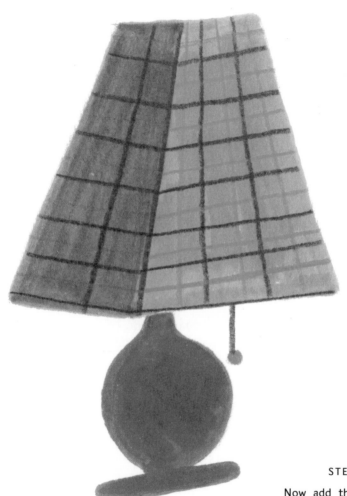

STEP 04

Now add the pattern to the lampshade. I used red and dark blue colouring pencils to do this. Draw a grid on both sides of the lampshade in one colour and then do the same with the other colour between the lines of the first grid.

Project 15

Cup and saucer

Drawing ceramics can be really fun because there are so many patterns and glazes you can include as surface decoration.

STEP 01

Sketch out your cup and saucer of choice. Include any patterns too, as this means you can use nice, contrasting colours. Or just trace the template on page 231. Don't worry about the smaller details yet; focus on the basic shapes.

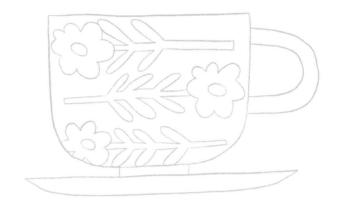

STEP 02

Block colour the cup and saucer using marker pens. I used a nice ochre colour for the saucer and a light blue and magenta pink for the cup, so I could go over the flower pattern with a darker colour that shows up really nicely!

Top Tip: Coloured pencil will show up really well over marker pens, but not vice versa.

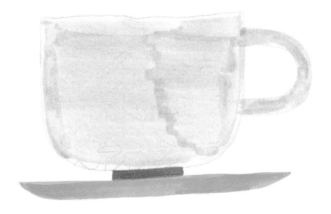

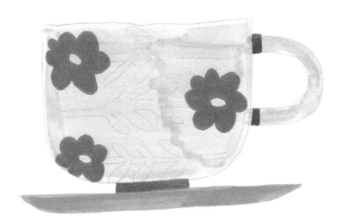

STEP 03

Next, use coloured pencil to add colour to the flowers on the cup. I opted for a red here, as red and blue are lovely complementary colours and work really well with each other (see page 15). As you can see, I also added some shadows to the handle of the cup. You can do this by choosing a darker shade to the one used for the handle colour and adding a small area where the handle meets the body of the cup.

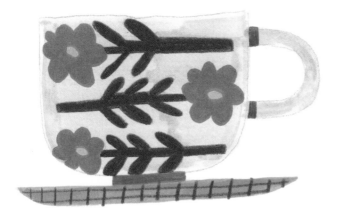

STEP 04

Finally, add in the last details. Using a dark green coloured pencil, colour in the stems and leaves of the flowers and add a chequered pattern to the saucer. Coloured pencils are perfect for adding smaller details and fine lines like this.

Project 16

Noodles

Illustrating food is something I really love doing - there is nothing better than being able to draw something really yummy! I've chosen noodles for this project, as I love putting in the wiggly lines.

STEP 01

Sketch out the bowl of noodles or trace the template on page 232. You could apply the techniques used in this project to draw spaghetti or any type of pasta as well. Drawing food and drink is a lot of fun – I love making the bowls look cute and the packaging fun and colourful.

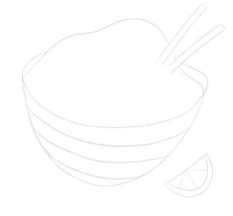

STEP 02

Block colour the noodles, the stripes on the bowl and the lime with marker pens. I used a light beige marker pen for the noodles. For the bowl I chose a bright pink and blocked in every other stripe to create a fun pattern. For the lime, I took two different shades of green, a light one for the inside and a darker one for the zest.

STEP 03

Choose the second colour for the bowl. Here, I decided on a coral colour for the remaining stripes.

STEP 04

Use dark blue coloured pencil for the chopsticks, so that they contrast strongly with the rest of the image. Also add some small details to the lime with green coloured pencil.

STEP 05

Now for the wavy noodles! Take a coloured pencil that is slightly darker than the base colour. Then, starting in the foreground, begin drawing curved shapes that look a little like wobbly rainbows. As you move the pencil backwards, alternate between where the noodles are sitting, so they look like separate mounds. Work around the chopsticks to make it look as if they are sitting in the noodles.

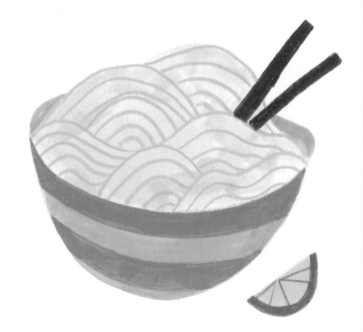

Project 17

Armchair

In this project, we are going to draw an armchair. This is such a fun project because you can play around with the shapes, colours and patterns on the soft furnishings.

STEP 01

Sketch out the armchair or trace the template on page 232. Once you've practised with this example, you could move on to drawing your favourite chair or perhaps add other elements to the piece like a houseplant or table!

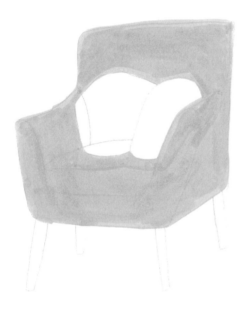

STEP 02

Colour in the main chair, leaving the legs and cushions blank at this stage. I used a bright yellow marker pen because it produces a lovely texture and makes the armchair look soft and comfy!

STEP 03

Next, use pink as a contrasting colour for one cushion and leave the other one blank. Refer back to the colour theory section (pages 14–15) to see which colours work well together. You can also colour in the legs of the chair – I used a dark blue for the front legs and a slightly lighter blue for one of the back legs to help give the armchair some dimension.

Top Tip: Objects in the background should always be a lighter tone than those in the foreground, as this helps to give your drawing depth!

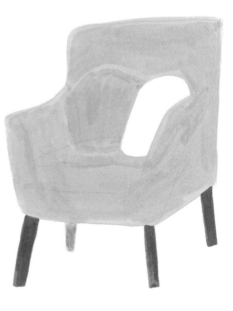

STEP 04

Now, add some shadows to the chair. Take a light blue marker pen and draw some thin lines down the sides of both cushions and also below them on the armchair. This helps to make it look as if the cushions are sitting on the armchair. If you wish, take a slightly darker orange/ yellow colour and go over the shape of the chair that you originally sketched out.

STEP 05

Now for the cushion details. You can get really creative here and do whatever you fancy! I decided to draw some big red flowers in coloured pencil on the pink cushion and added some fancy blue tassels to the corners. Then, for the white cushion, I used a dark blue coloured pencil and drew a grid pattern.

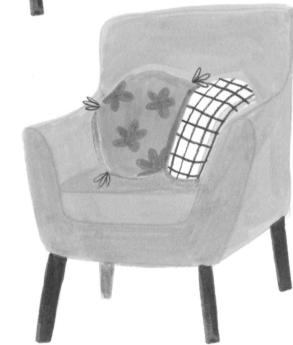

Project 18

Fruit bowl

Fruit bowls are objects that I love drawing because of the juxtaposition of the organic shapes and the geometric bowl. They're also fab to add to a still-life scene.

STEP 01

Sketch out the fruit bowl or trace the template on page 232.

STEP 02

Next, take a yellow marker pen and block colour all the lemons. Then, using two different purples (I used a lighter purple marker pen and a darker purple coloured pencil), colour in the outside of the bowl with the lighter shade, leaving the frilly pattern blank, and use the darker one for the inside of the bowl - be careful around the leaves and lemons here.

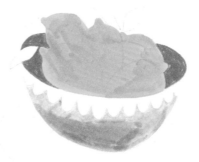

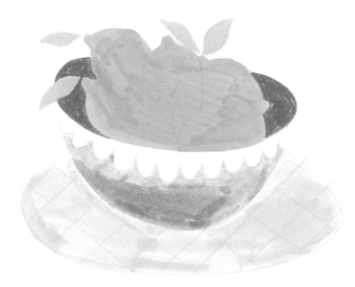

STEP 03

Now take a light green marker pen and carefully colour in the leaves. Use a light pink marker pen for the plate.

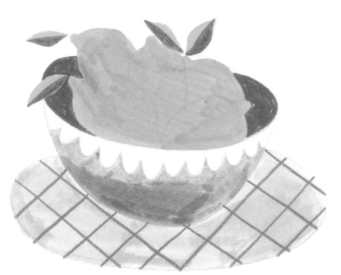

STEP 04

Then, with a darker green coloured pencil, go over one half of each leaf. This adds a bit of dimension and interest. For the plate underneath, take a bright red coloured pencil and draw a simple grid pattern. I chose red because this really complements the pink base colour.

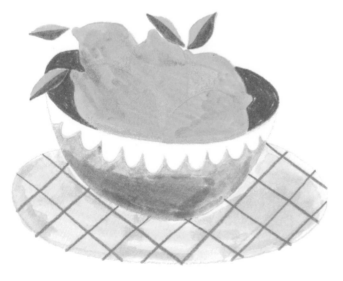

STEP 05

Finally, add some shadows to the lemons. At the moment they are just one big blob, so we need to differentiate them from one another. Take a blue pencil and, starting from the back, add some blue to any area overlapped by another lemon. Use a light pressure here when you begin shading – you can always build it up if you want a darker colour.

Project 19

House

I drew a very simple house
here, but you could add
all sorts of details such as
window boxes, flowerpots
and bushes. You could
even put someone in
one of the windows!

STEP 01

Sketch out a very basic shape for the house, with a triangular roof and little chimney, or trace the template on page 232.

STEP 02

Start with a lighter colour for the bricks of the house and a darker colour for the roof. This works well because you can then add nice shadows to the brickwork at the top where it is covered by the roof. I chose marker pens for this stage, as I love how playful they look and the texture that they give.

For now, colour the main building of the house all in one colour.

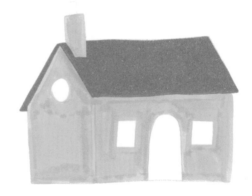

STEP 03

Now add the colour for the door and windows. I selected a vibrant blue here to ensure it stands out nicely against the pink. I used a coloured pencil here, as I wanted the blue to be very bright and I needed a nice fine line too.

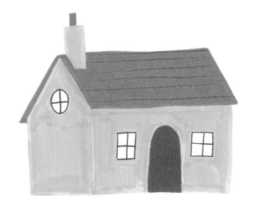

STEP 04

Next, add some little details to the building, such as a few bricks and the tiles on the roof. I also used coloured pencil here for a nice crisp line. Marker pens also work well for this, but would create a softer effect.

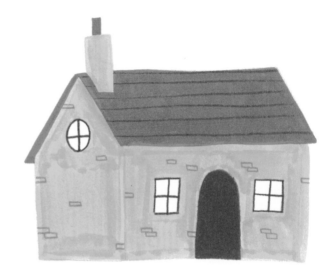

STEP 05

The final step for this piece is to add the shadows. I used a blue marker pen to block colour the side of the building. As you can see, the colour is slightly transparent, so you get a nice blended effect.

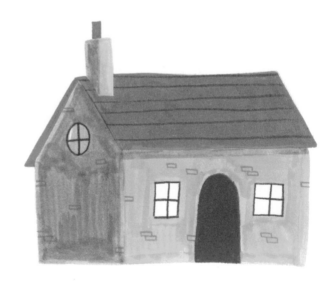

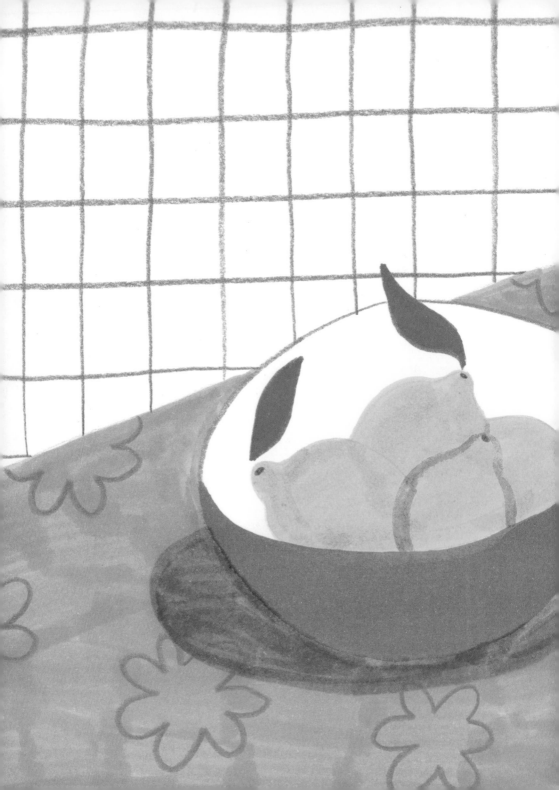

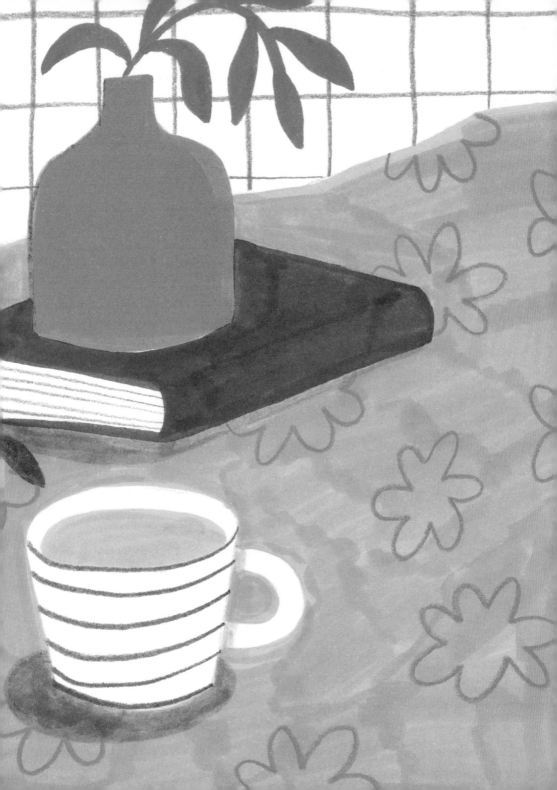

Project 20

Cat

For our first animal,
I decided to go for a cat.
I designed the body with
simple shapes, so this is a
great project to begin with.

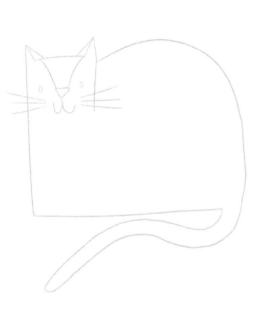

STEP 01

Sketch out the cat shape with a really simplified, rounded mound shape for the body and head. Add a tail at the bottom and two triangular ears. Alternatively, trace the template on page 232.

STEP 02

I decided to colour my cat in pink. That is the joy of illustration – you don't need to use lifelike colours and can have lots of fun with it! Consider your drawing before colouring it all in, so some portions are left blank for adding small details later. I used a pink marker pen, leaving white spaces for the tip of the tail, inside of the ears and the nose area on the face.

STEP 03

Next, take a blue marker pen and add the shadows. Draw a horizontal line down the side of the head to separate it from the body. You can also draw in the back leg and foot here, to give the cat some shape. To do this, simply add two small mounds: one for the leg and a tiny one for the foot to the body of the cat.

STEP 04

Now add the details for the cat's face. Use dark grey coloured pencil to add the whiskers, mouth, eyes and claws. Then take a pink pencil and colour in the inside of the ears and the nose! Make sure your pencil is sharp for this part, so the lines are nice and neat.

STEP 05

Finally, add some texture to the body of the cat. This could be stripes, spots or a nice, fluffy texture, as I have here! I used a darker pink coloured pencil to add some scruffy-looking marks to make the cat look as if it has some long fluffy fur!

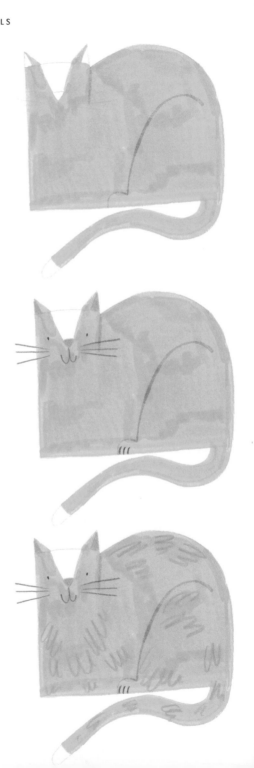

Project 21

Antelope

Antelopes are so wonderful to draw - I love their expressions and you can create amazing detail on their horns. It's a good idea to draw from a photo to make sure you have a rough idea of proportions, but then you can use a little artistic licence to make it your own.

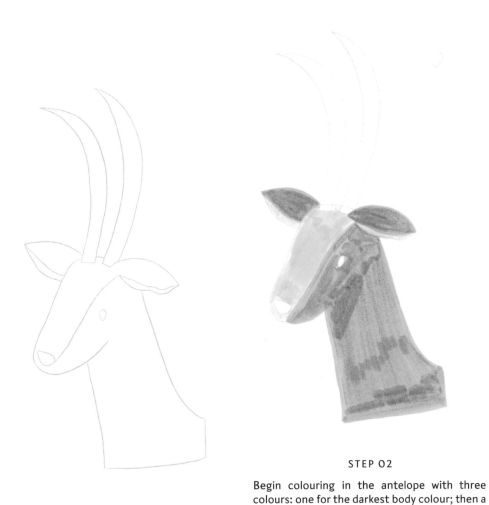

STEP 01

Sketch out the antelope or trace the template on page 233.

STEP 02

Begin colouring in the antelope with three colours: one for the darkest body colour; then a slightly lighter beige for the nose; and a pink for the underside of the ears. I used marker pens.

STEP 03

Next, colour in the horns. For these, I used a light grey marker pen and then I used the same colour to add a shadow under the chin. Create the shadow by colouring a small, elongated triangle where the head casts a shadow on the body. This is always a really nice touch, as it gives your animals much more dimension.

STEP 04

Now it's time for the coloured pencil details! This is my favourite part, as it really brings your illustrations to life. For the horns, use a dark grey pencil to add horizontal lines that mimic the patterns on the surface. Then use a black pencil for the eyes and nose. Lastly, use a dark brown coloured pencil to add some scribbly texture to the ears and the body of the antelope to make it look a bit fluffy!

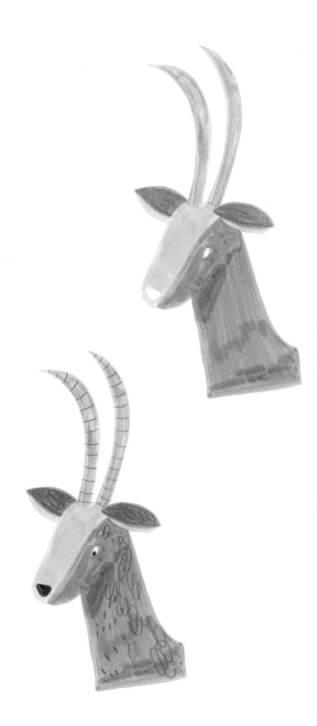

Project 22

Dog

Dogs are just my favourite
thing ever, so I can't wait
to show you how to draw
a fun little dalmatian.

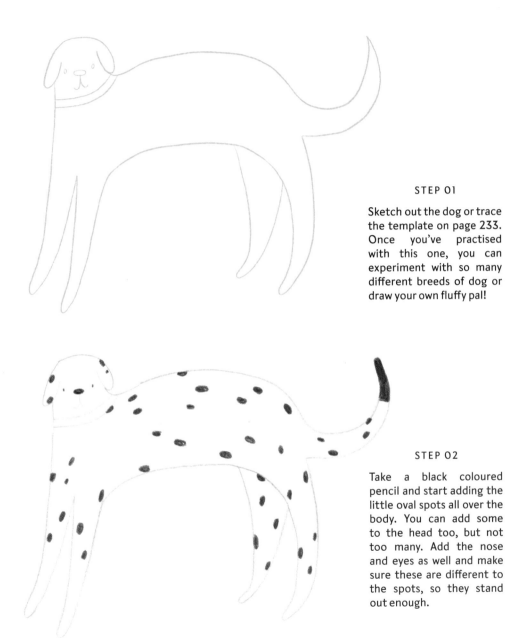

STEP 01

Sketch out the dog or trace the template on page 233. Once you've practised with this one, you can experiment with so many different breeds of dog or draw your own fluffy pal!

STEP 02

Take a black coloured pencil and start adding the little oval spots all over the body. You can add some to the head too, but not too many. Add the nose and eyes as well and make sure these are different to the spots, so they stand out enough.

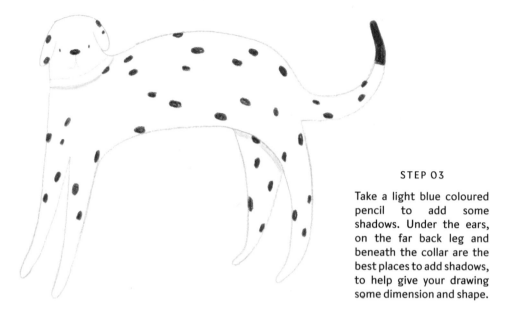

STEP 03

Take a light blue coloured pencil to add some shadows. Under the ears, on the far back leg and beneath the collar are the best places to add shadows, to help give your drawing some dimension and shape.

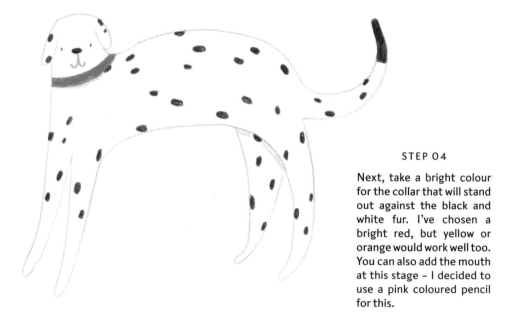

STEP 04

Next, take a bright colour for the collar that will stand out against the black and white fur. I've chosen a bright red, but yellow or orange would work well too. You can also add the mouth at this stage – I decided to use a pink coloured pencil for this.

Project 23

Tropical bird

I've included a bird in the
animal section because
I love drawing their
amazingly colourful
plumage. You can go wild
with all the rows of feathers
in this soaring composition.

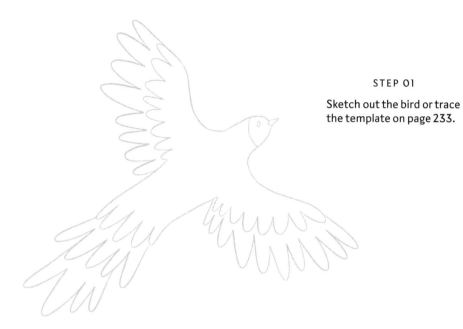

STEP 01

Sketch out the bird or trace the template on page 233.

STEP 02

Start with the lightest colour for the head and tail feathers, but leave the eye white. I used a light mint-green marker pen for these areas. For the next sections of feathers, try using an orange marker pen.

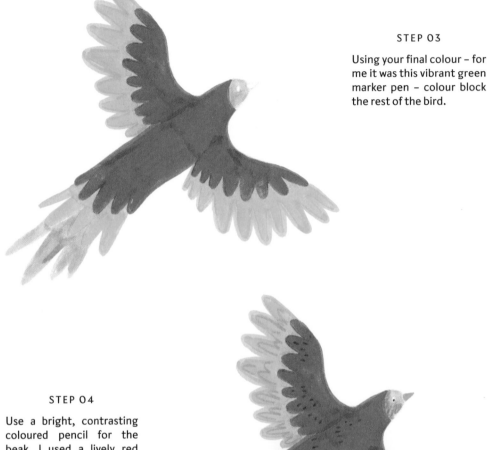

STEP 03

Using your final colour – for me it was this vibrant green marker pen – colour block the rest of the bird.

STEP 04

Use a bright, contrasting coloured pencil for the beak. I used a lively red to contrast with the mint green. Make sure the pencil is nice and sharp, so you get a really neat little triangle for the beak shape. Add a small, blue dot for the eye. Use a dark green pencil to add some little specks all over the bird's body and feathers. Finally, using darker coloured pencils, add a few 'U'-shaped squiggles to the tail and wings for extra texture.

Project 24

Fish

Let your imagination
run riot when it
comes to drawing this
creature of the deep.

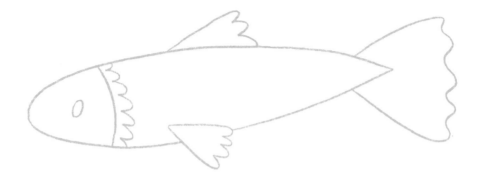

STEP 01

Sketch out the fish or trace the template on page 233. You can change up the pattern if you like – maybe try spots, stars or a chequered pattern!

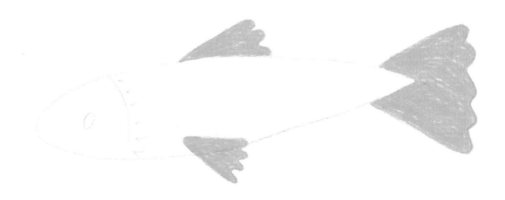

STEP 02

Begin by using a coloured pencil to colour in all of the fins with a block colour. I chose a lovely, bright, golden yellow here.

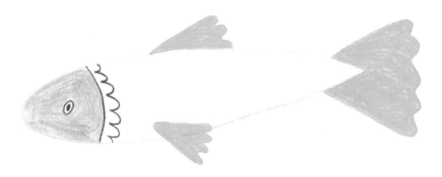

STEP 03

Next, take a contrasting coloured pencil such as this lilac for the head and a darker purple for the details around the head and eye.

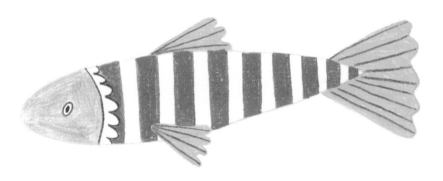

STEP 04

Finally, add colour to the fish's body. I used a bright red coloured pencil for this and coloured in every other stripe. Use the same dark purple for the lines on the tail and fins of the fish too.

Project 25

Snake

Snakes are such fun to
illustrate because you
can really play around
with colour and pattern.
Remember, the snake
doesn't need to look lifelike,
so get creative with it!

STEP 01

Sketch out the wiggly snake
or trace the template on
page 233.

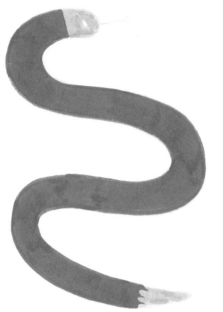

STEP 02

Colour in the entire snake, apart from the tail and the head, using a bright blue marker pen. Fill in the tail and the head with a mint-green marker.

STEP 03

Add some lines across the body using a darker blue marker pen. Also add the tongue with a red coloured pencil and a small black dot for the eye. Include some scalloped detail using coloured pencil near the tail and some stripes by the head to add more interest.

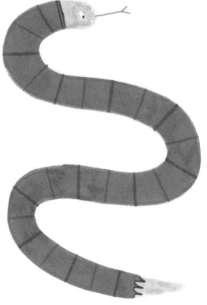

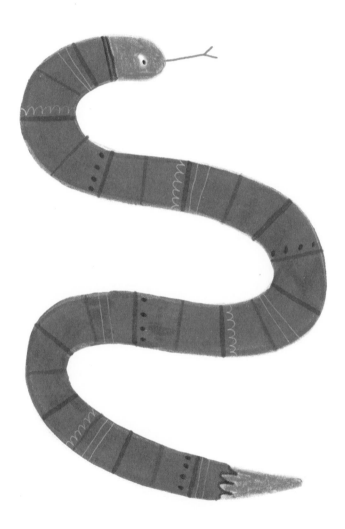

STEP 04

Now add the final details. Pop some small dots along some of the lines on the body with a dark green coloured pencil as well as a bright green on top of the head and tail. For a final flourish, use a white coloured pencil to add some loops and lines to the body of the snake too.

Project 26

Seal

Drawing this seal is a great project to practise adding texture to your animals. Playing with texture is the perfect way to add dimension and depth to illustrations.

STEP 01

Sketch out the seal or trace
the template on page 235.

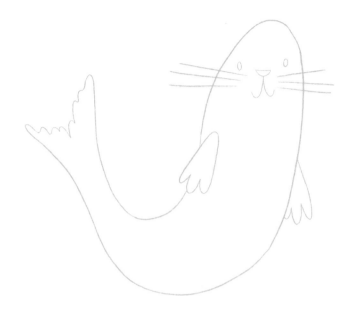

STEP 02

Using a light grey marker
pen, colour in the seal's
body. Now colour in the
flippers with a darker grey.
You can also add details to
the face at this point with a
little upside-down triangle
for the nose , two lines for a
smiley mouth and two dots
for the eyes.

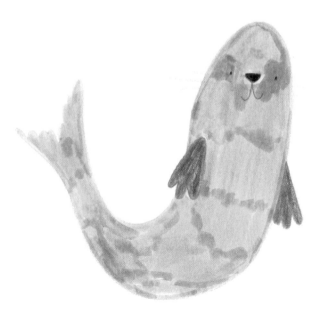

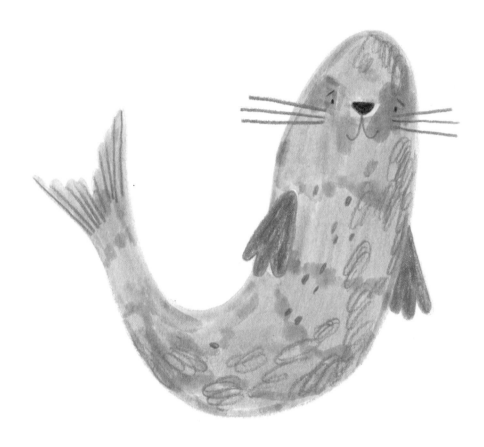

STEP 03

Now it's time for all the texture. Start by adding some scribbly marks and speckles with a grey coloured pencil to give the seal's fur a mottled appearance. This helps to give the illustration some dimension and stops it looking too flat. You can also add some lines to the tail and for the whiskers using a sharp pencil to ensure they are nice and neat.

Project 27

Leopard

Spotty leopards are
a joy to draw and I've
chosen a bit of a Sphinx-
like pose for this one.

STEP 01

Sketch out the shape of the leopard or trace the template on page 235. Pencil in the eyes and nose, so you get the right placement ahead of the next stage.

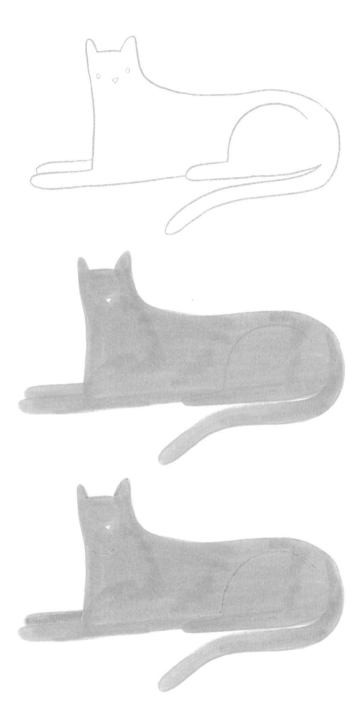

STEP 02

Now it's time to colour block the whole shape apart from the nose. I used a golden yellow marker pen for this, but you can use any colour – maybe even go for a pink leopard!

STEP 03

Now take a blue marker pen to add the shadows and details on the legs and ears. Colour in the furthest front leg, add a curved line under the leopard's chin and one for the insides of the ears. You can also add the lines for the back leg and foot.

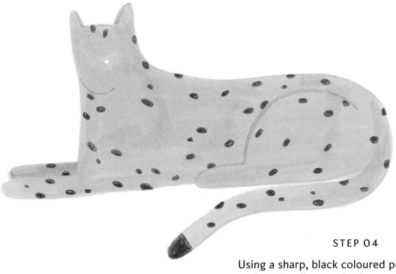

STEP 04

Using a sharp, black coloured pencil, add some oval spots all over the leopard's body. Add a few to the face, but not too many or the facial features may get lost. You can colour in the spots quite randomly here, as that gives the best natural look. Also add a black tip to the tail.

STEP 05

Using the same black pencil, draw an upside-down triangle for the nose and add two small dots for the eyes. Using a fine pink marker pen, colour some small triangles for the inside of the ears and some small lines for the eyebrows. You can also add three lines in blue pencil to either side of the nose for the whiskers!

Project 28

Octopus

Next up is an octopus. They're such fun to draw with all their wiggly tentacles and big heads!

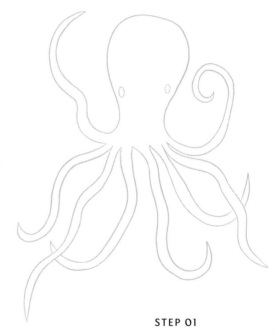

STEP 01

Sketch out the shape of the octopus or trace the template on page 234. Include the eyes in this step too, so you remember to leave a white space for them.

STEP 02

Now block colour the whole shape apart from the eyes. I chose a light lilac marker pen for this.

STEP 03

Now add the eyes with a black coloured pencil. Use a light blue marker pen to add shadows to the tentacles that are behind other tentacles.

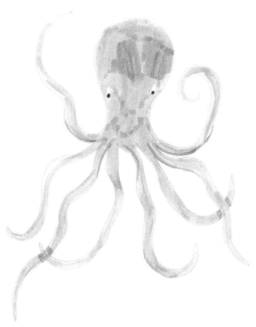

STEP 04

Now add some of the details to the octopus's body and tentacles. I used a purple coloured pencil for the oval dots on the head and the fine end of a marker pen in ultramarine blue for the dots on the underside of the tentacles.

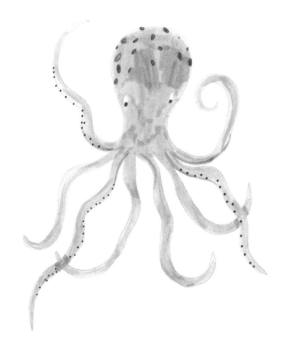

STEP 05

Finally, using a pink coloured pencil, add some texture to the body and tentacles. You could use any colour here, as this is just to add another element to the illustration. Here, I opted for a pink, as it works harmoniously with the cool tones of the blues and purples of the base layer and dotty details.

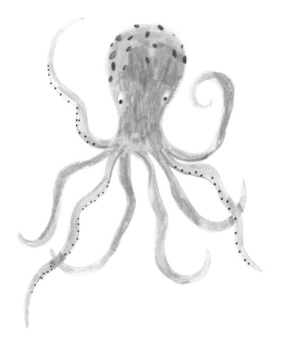

Project 29

Chicken

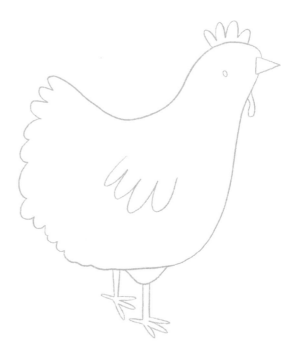

Why not switch up
the colouring of this
farmyard favourite
and go for pink?

STEP 01

Sketch out the chicken shape and
add the beak, legs, wing, comb (on
top of the head), wattle (beneath the
beak) and eye. Alternatively, trace the
template on page 235.

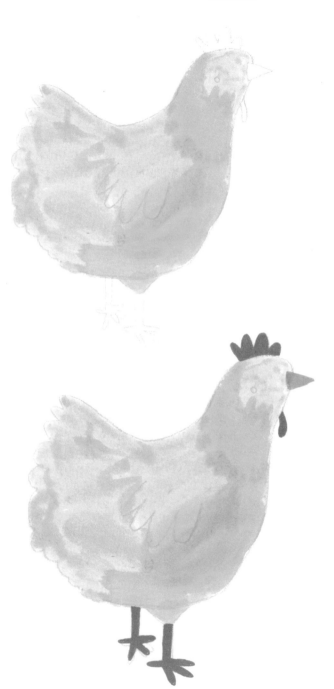

STEP 02

Choose a base colour for the chicken and block in the whole body with marker pen, leaving the beak, legs, wattle and comb blank.

STEP 03

Using marker pens, colour in the beak, legs, wattle and comb. I suggest using red to contrast with the pink and a nice vibrant orange for the beak. Use the smaller end of the marker pens here, so you can get much finer and more precise lines.

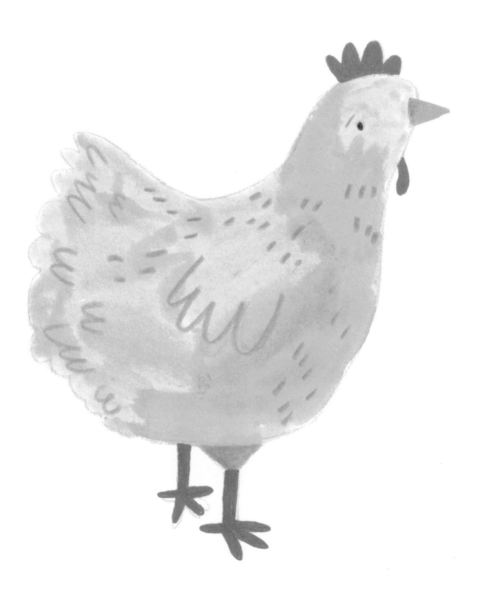

STEP 04

Finally, add some feathery details. Use a dark pink coloured pencil for this to get some nice fine lines. Also use an orange to add some little specks to the back of the chicken, the dark pink for the eyebrow, and black for the little eye.

Project 30

Whale

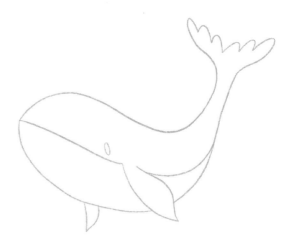

We will give this
whale an ocean
background to put
it into context. This
can be applied to
any piece included
in the book.

STEP 01

Start by sketching out the whale or
trace the template on page 234.

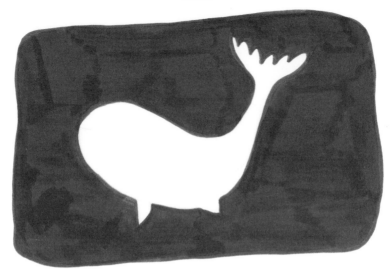

STEP 02

First, we're going to add the background. Take a dark blue marker pen and carefully outline the shape of the whale. Then draw a rounded rectangular border and fill in the space with the marker pen.

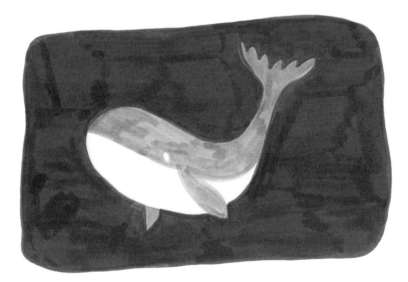

STEP 03

Now we can move on to the whale. Use a light blue marker pen to colour in the top section of the whale, leaving the bottom section white. Colour in the fin at the back, as well as the front fin, because this is the same colour as the top of the body. Leave the bottom section of the whale and the eye blank.

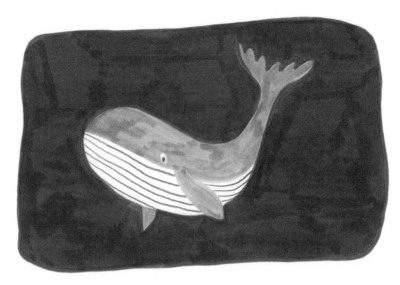

STEP 04

For the bottom half of the whale, take a dark blue coloured pencil and draw lines all the way along. Then, for the eye, use a black coloured pencil to make a small dot in the space you left white at the start.

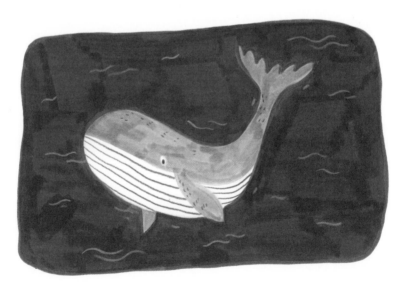

STEP 05

Lastly, draw some little waves on the dark background with a light blue coloured pencil. This helps to put the whale into context and makes it look as if it is swimming in the sea!

Project 31

Lizard

Drawing a lizard is a great project to get you playing with fun colours – remember, it doesn't need to be lifelike, so let your imagination loose!

STEP 01

Sketch out the lizard or trace the template on page 235.

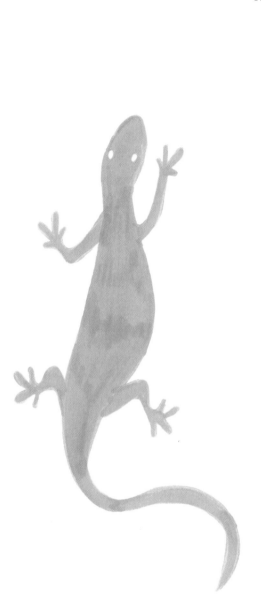

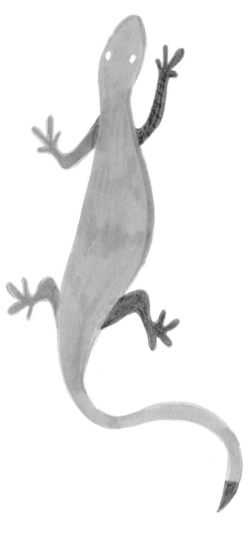

STEP 02

Block colour the whole lizard in one colour. I used a light green marker pen for this. Don't forget to leave two white spaces on the head for eyes.

STEP 03

Next, colour the legs on the lizard's right side with a dark green marker pen. Add a few lines to the top-right leg. This side will all be in shadow. For the legs on the left side, take a light blue marker and colour over those too. These legs are also in shadow, as they are below the body, but you don't want them as dark as the others. You can add some shadow to the right-hand side of the body too. Do this with the light blue marker and make a thin line all the way down.

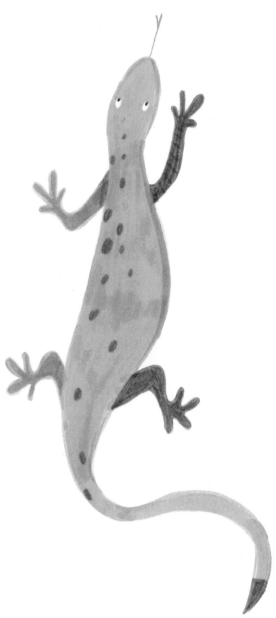

STEP 04

The final step for the lizard is to add some fun details. Two black dots for the eyes and a little red tongue finish the head. I decided to use coloured pencil for all the details here. Take turquoise and lilac pencils to add dots to the lizard's back.

Project 32

Tiger

The tiger is another favourite creature of mine, and you'll often see these magnificent creatures in my work. I've gone for a very chilled-out pose for this big cat.

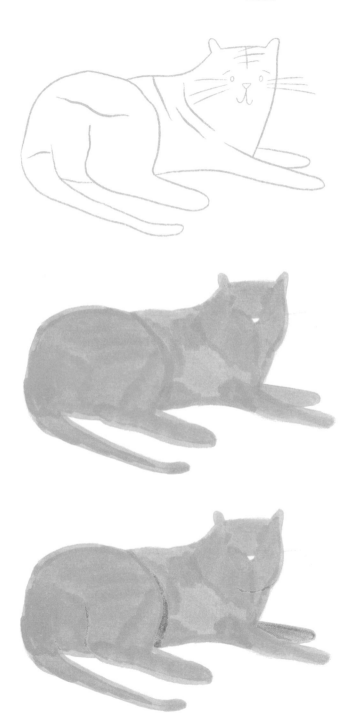

STEP 01

Sketch out the tiger or trace the template on page 235.

STEP 02

Block colour the whole of the tiger's body apart from the nose. I used a bright orange marker pen here, as this makes the fur look a bit bushy.

STEP 03

Next, use a light blue marker pen to add some shadow to the front leg behind the one in the foreground and to the back leg where it overlaps the body. Add a line of shadow underneath the tiger's chin and just where the tail joins the body too.

STEP 04

Now for the stripes! I chose a really dark green coloured pencil here, but you could use any dark colour you want. Add some stripes over the body, and make some wider than others or a slightly different shape because it will make them look more lifelike. Add stripes to the face, tail and legs too. Don't forget to colour the tips of the ears in the dark green too.

STEP 05

Include two little dark brown dots for the eyes. Use pink for the eyebrows and upside-down, triangular nose. Give your tiger a smiley mouth and some whiskers with the same dark brown. Add the tiger's paw prints in the dark green too.

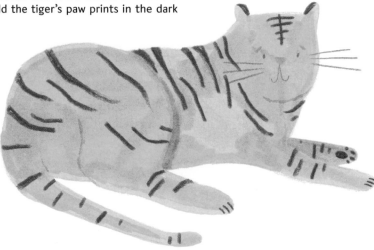

Project
33

Bear

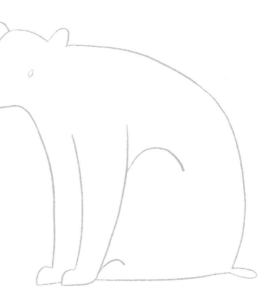

Bears are really fun to
draw because they have a
lovely, simple body shape
and you can experiment
with texture on the fur to
make them look fluffy.

STEP 01

Sketch out the bear shape
or trace the template on
page 234.

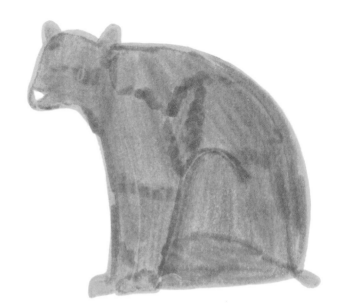

STEP 02

Using a brown marker pen, block colour all the bear apart from the nose. You should still be able to see the lines of the sketch under the marker pen, so you can go over them later.

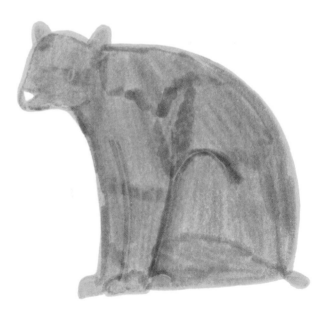

STEP 03

Next, with a light blue marker pen, go over the lines for the front and back legs. Do the same for the bear's chin. This will help to give these areas some definition against the rest of the body and give the bear some dimension.

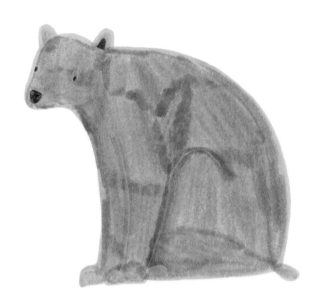

STEP 04

Now, taking a black coloured pencil, draw a triangle for the nose and inner ear and two small dots for the eyes.

STEP 05

To add some texture to the bear's body, take a dark brown coloured pencil and make some scribbly marks to look like fur. This is a really good technique to apply to lots of different animals to make their fur look fluffier! And add some darker little specks to the body and top of the head with a darker brown coloured pencil. Use the same pencil to add claws to the paws.

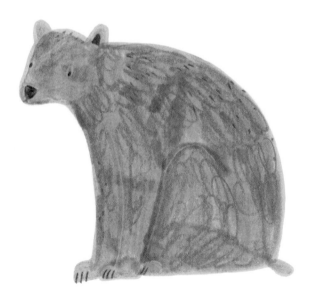

Project 34

Bumble bees

For this project, I've added another element, just to show you how creatures can be put into context!

So, for these little bees, I've added a flower for them to buzz around!

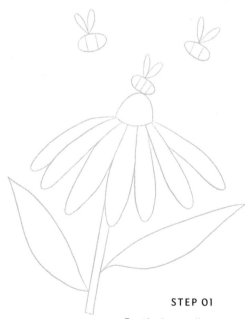

STEP 01

For the bees, all you need to do is sketch out an oval with two upside-down teardrops for the wings. Or you can trace the template on page 234.

STEP 02

Start by colouring in the stem, leaves, the middle of the flower and the bumble bees' bodies. Use marker pens for this and then add the details with coloured pencil later. To get the tips of the leaves really sharp, use a light pressure. This will produce a nice fine line and help you get a clean point!

STEP 03

Since we are drawing a daisy here, we should keep the petals of the flower white, but they also need a bit of definition. So use a fine light blue marker pen for the outlines of the petals to make them clearer, although you can use any light colour for this. Use a green coloured pencil that matches the colour of the stem for the veins on the leaves.

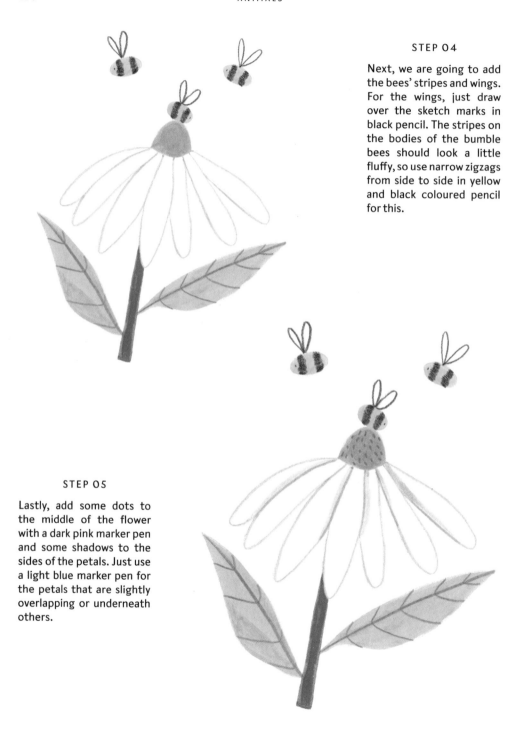

STEP 04

Next, we are going to add the bees' stripes and wings. For the wings, just draw over the sketch marks in black pencil. The stripes on the bodies of the bumble bees should look a little fluffy, so use narrow zigzags from side to side in yellow and black coloured pencil for this.

STEP 05

Lastly, add some dots to the middle of the flower with a dark pink marker pen and some shadows to the sides of the petals. Just use a light blue marker pen for the petals that are slightly overlapping or underneath others.

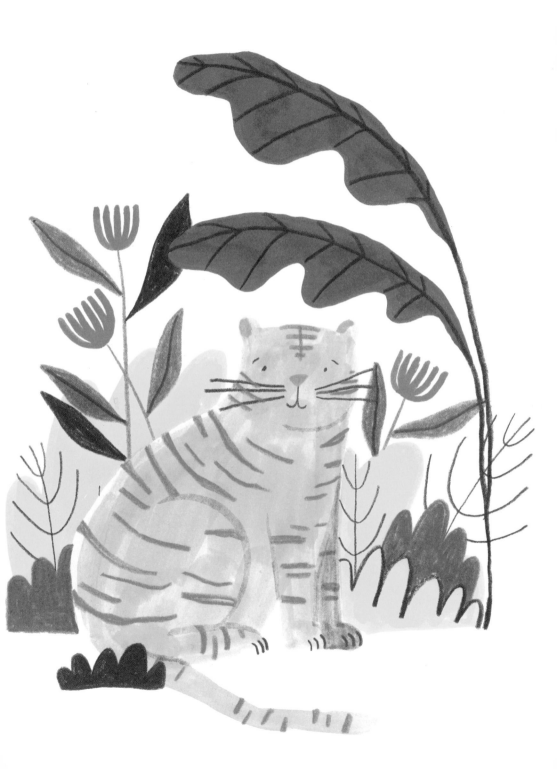

Project 35

Gingham pattern

Gingham is such a fun pattern to draw and super simple too! I use chequered patterns a great deal in my work, whether it's to decorate clothing, vases or a tablecloth – they're so versatile.

STEP 01

There is no template for this one, so there's no need to trace anything. Don't worry, this design is super simple, so you won't need one. Start by drawing four vertical lines in a bright red marker pen. Leave about twice the thickness of the line between each one.

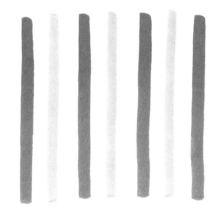

STEP 02

Next, take a light blue marker pen and draw three vertical lines between the first four red ones.

STEP 04

Using a bright pink marker pen, draw four horizontal lines over the top, beginning the chequered pattern.

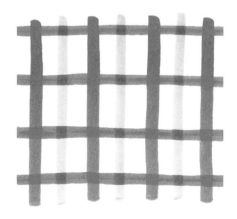

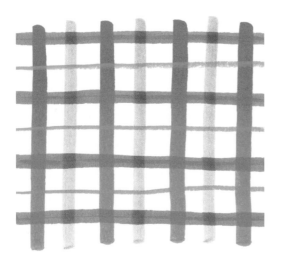

STEP 05

Then, using a bright orange coloured pencil, draw three horizontal lines between the pink ones.

STEP 06

Finally, take a thick, light pink coloured marker pen and draw another three horizontal lines below each orange line and three vertical lines to the left of each blue line.

Top tip: I love playing with different colours for these chequered patterns and the fact that you can create new colours where the lines intersect.

Project 36

Repeat Pattern – Fruit

For this fruit pattern
I used two complementary
colours: orange and purple.
Using these shades makes
the pattern really pop!

STEP 01

Sketch out the fruit pattern
or trace the template on
page 236.

STEP 02

Start by colouring in the oranges. I suggest using only coloured pencils for this pattern, so you can see how lovely an illustration looks all done in that medium.

STEP 03

Now take a darker shade of orange and add some of that to the oranges too. This helps to give the fruit a bit of extra texture and dimension.

STEP 04

Next, take a deep red and colour in the stalks of the oranges. Then, with two different shades of green, colour in the leaves. Make sure your pencil is nice and sharp here, so you can get neat points for the tips of the leaves.

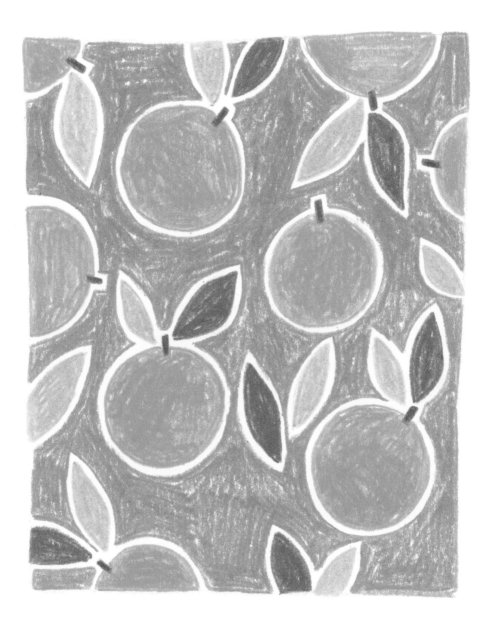

STEP 05

Finally, you can add a background. For this, I chose a lovely lilac colour. When adding this background, leave a little white halo around the elements of the pattern for a fun visual effect.

Project 37

Repeat Pattern – Stars

This pattern uses a limited colour palette - only two shades! This really pushes you to think about exactly where your colours and marks should go. Limited colour palettes often look very striking.

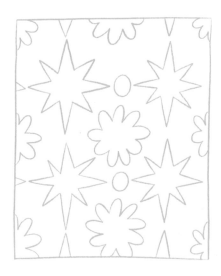

STEP 01

Sketch out the starry patterns, or you can trace the template on page 236.

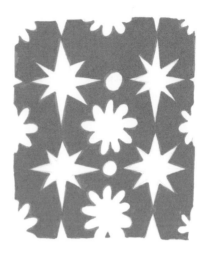

STEP 02

Block colour the whole background using a bright red marker pen. I really love the texture and blobby marks you get when covering large areas with these pens.

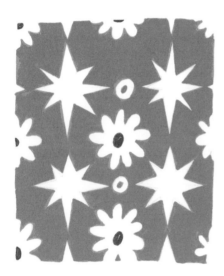

STEP 03

Grab a dark blue coloured pencil and scribble a circle in the centre of each flower. Then add a red circle using a coloured pencil inside the dots.

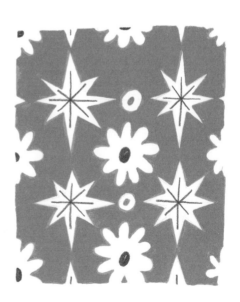

STEP 04

Next, we're going to add some linework stars to the centre of the star shapes. Using the dark blue pencil, start in the middle of the star and draw outwards to each of the points. Repeat for all the stars.

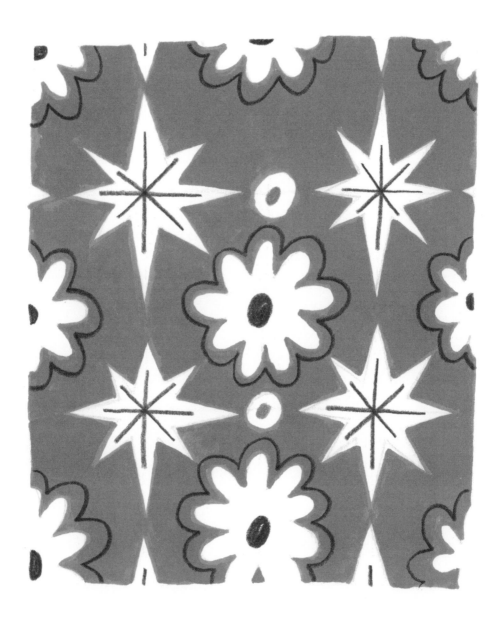

STEP 05

Finally, on the outside of the flower shapes, mimic the outline with the dark blue pencil to add a little more detail.

Project 38

Floral pattern

This pretty pattern features some wonderfully blousy blooms and bright leaves that contrast against the pale background.

STEP 01

Sketch out the floral pattern, or you can trace the template on page 236.

STEP 02

Colour block in the pattern background using a light pink marker pen.

STEP 03

Next, using two shades of green marker pen, colour in the leaves. Use a light pressure here to ensure you achieve a nice sharp point at the tips of the leaves.

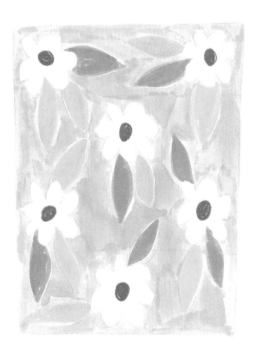

STEP 04

Take a bright red coloured pencil and add a scribbly circle to the centre of each flower.

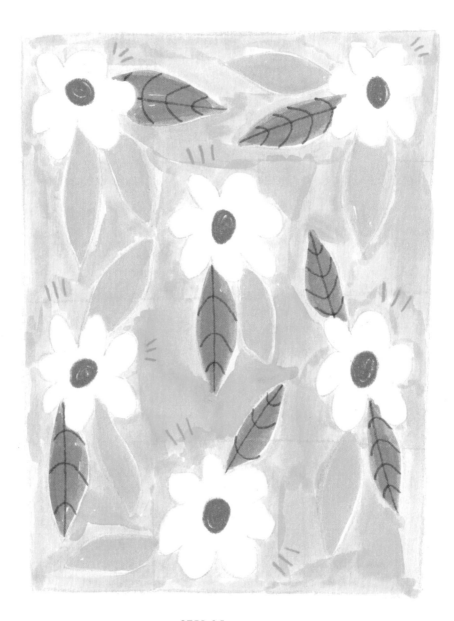

STEP 05

Then to finish the pattern off, take a finer, dark green marker pen and add the veins to the leaves. To do this, add a line straight through the middle of the leaf, then draw a few curved lines across the leaf over the top of the first line. Use a pink coloured pencil in a darker shade to the light pink to add groups of three lines in random places on the background.

Project 39

Stem pattern

This fresh pattern shows
just what you can achieve
with only one colour.

STEP 01

Sketch out the stems or trace the
template on page 236.

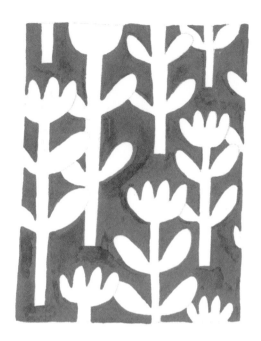

STEP 02

Next, take a green marker pen and colour block all the background. Be really careful here to leave the stems blank and try not to go over the lines too much. This is called negative space, which is a nice way to block out shapes and create fun patterns. Use the tip of the marker pen and a light pressure when going round the particularly fiddly parts.

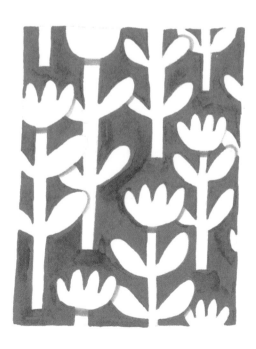

STEP 03

Now, take a light blue marker pen and draw a small line under each flower head at the top of the stem, to help distinguish between the two. Also add shading to the leaves where they are covered by another leaf or flower.

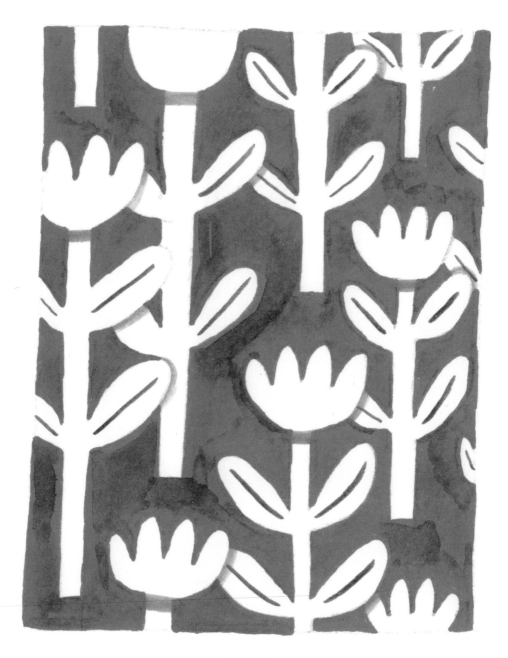

STEP 04

Finally, with a thinner green marker pen, add a line down the centre of each leaf.

Project 40

Diamond pattern

I love a graphic diamond pattern; it always reminds me of grand Spanish tiled floors. Here, I've combined angular shapes with some rounder florals.

STEP 01

Start by sketching out the diamond pattern or trace the template on page 237.

STEP 02

First, choose two coloured marker pens and alternate between them to colour in all the diamonds. Use a light pressure for this to achieve a nice, neat line and sharp point. I used a lilac and turquoise for my pattern. I chose these colours because I think they contrast well! If you need a little guidance here, refer to the section at the front of the book on colour (see pages 14–15).

STEP 03

Next, go ahead and colour in the circles. I opted for a bright yellow coloured pencil for this and drew quite scribbly lines. Yellow is a great colour to use against shades with a cool tone - like this turquoise and lilac.

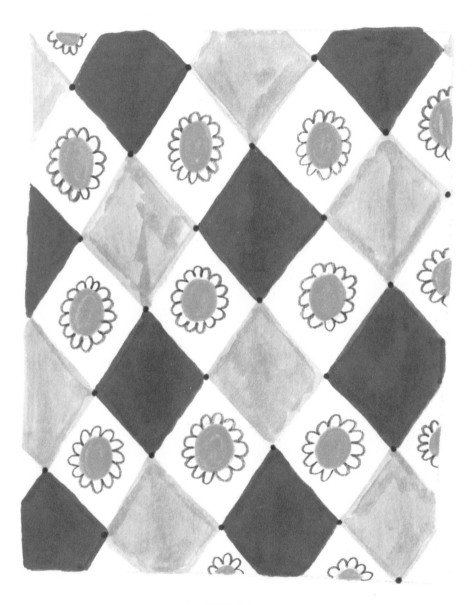

STEP 04

Now for the details! Use a blue marker pen to add a blue dot where each of the diamonds meets, and turn the yellow circles into little flowers by adding a small border of semi-circles around each one with a coloured pencil.

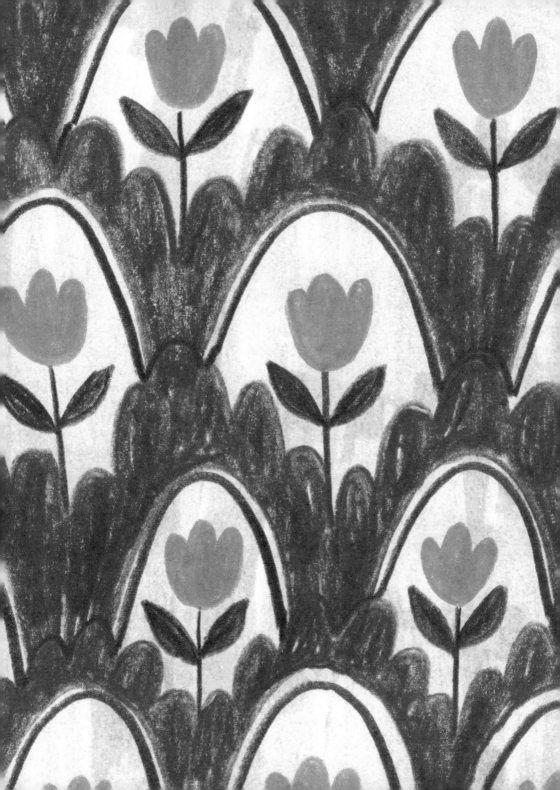

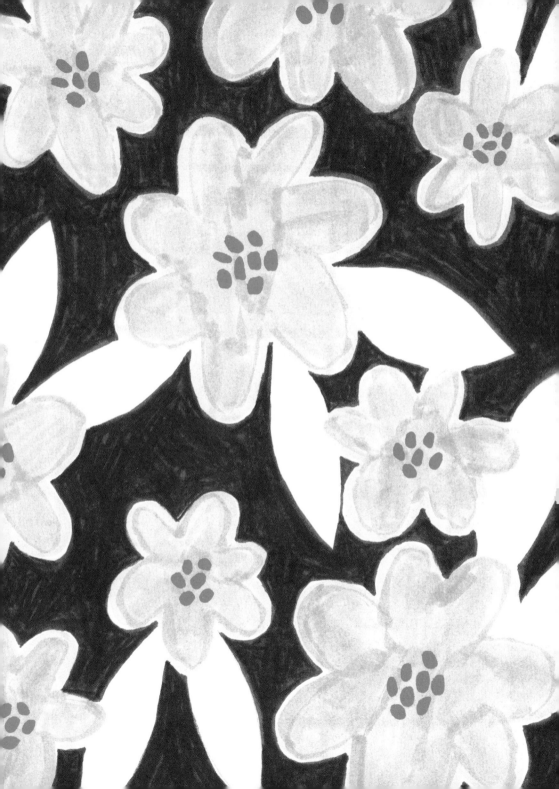

Project 41

Mermaid

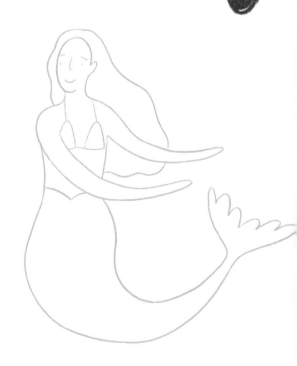

For this project, we are going to draw a mermaid. There are no rules when it comes to mythical creatures, so be as creative as you want!

STEP 01

Sketch out the mermaid or trace the template provided on page 237.

STEP 02

First, add all the flesh tones and the mermaid's blue hair using marker pens. For the wisps of hair over the face, make sure you use a light pressure to get a finer line.

Next, using mint-green and turquoise-blue marker pens, begin colouring in the tail. Start at the tip using the turquoise-blue and work two-thirds of the way up the tail. Then, taking the mint-green colour, draw over where you stopped with the turquoise to blend the colours together (see page 10). I used water-based marker pens because they blend so nicely with one another.

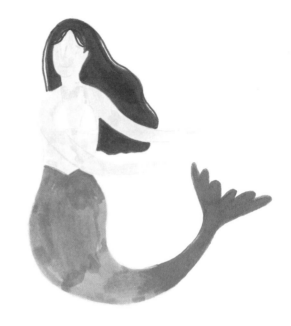

STEP 03

Take a light blue marker pen and add the shadows beneath the chin and on the body where the arm is crossing over to the right.

Now add the bikini and tail details using a dark turquoise colour. Make sure your pencil is sharp for this, so you get precise lines. To create the scale effect on the tail, make small, semi-circle shapes along the top. Add more scales underneath, so they are slightly off-centre from the first row. Keep going all the way down the tail until you reach the tip Then add some lines to the end of the tail.

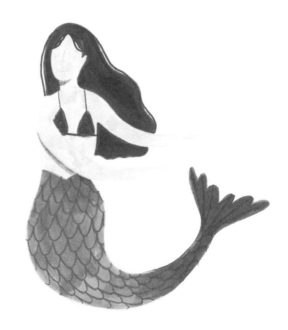

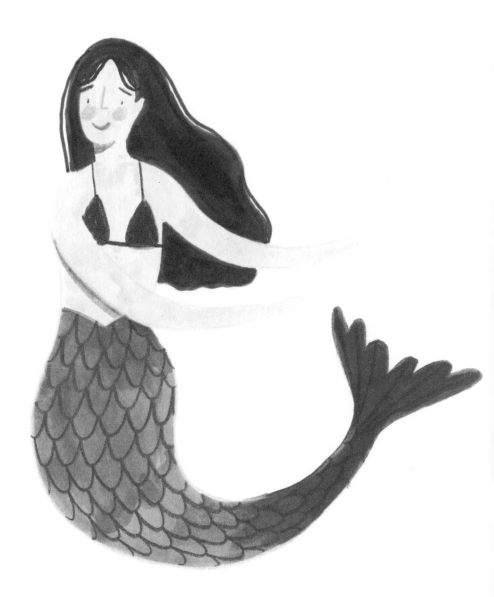

STEP 04

Lastly, add the details for the face. Use a bright blue coloured pencil for the eyebrows to match the hair and add two small black dots underneath these for the eyes. Then add the nose and two little rosy cheeks using the same pale orange coloured pencil. Simply add a small curved line in bright red pencil for the smiley mouth.

Project 42

Face 1

People are one of my favourite subjects to draw. I love coming up with characters and then thinking about what clothes and accessories they would like to wear and what sort of expression they'd have on their face.

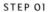

STEP 01

Sketch out the face or trace the template on page 237.

STEP 02

Colour block the whole face and any other skin that is on show (you can cover over any sketched-in features, but leave the mouth blank at this stage). You should still be able to see the pencil marks through the colour as you'll need to go over these later. I used a medium-brown marker pen for the face here. Use a yellow marker pen to block in the dress.

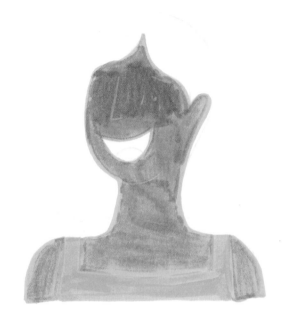

STEP 03

For the hair, take a black marker pen and carefully colour it in. Use a light pressure so you can achieve a thinner line around the ears and forehead.

Add some shadows to the face and dress with a light blue marker pen. To do this, draw a triangular shape under the chin and add lines to one side of each dress strap.

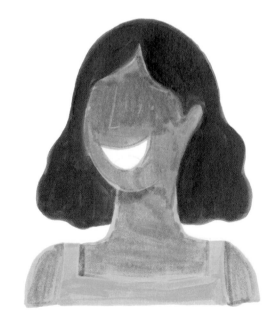

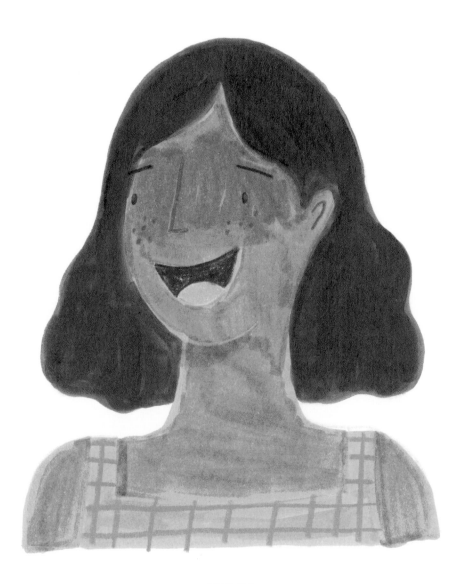

STEP 04

Lastly, add all the details to the face and clothes. Take a bright orange coloured pencil and make some horizontal and then vertical lines over the yellow dress to form a grid pattern.

For the face, using only coloured pencils, add two small dots for the eyes and two slanted lines for the eyebrows. Then add the nose with a brown that is darker than the skin tone you used. For the smile, colour in the top section of the mouth black and the tongue in a light peach colour.

Project 43

Face 2

Drawing people and faces can be such a joy! I love thinking up different personalities for them and figuring out what their style would be like.

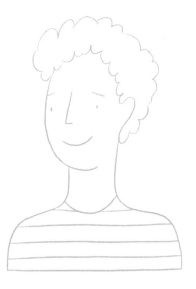

STEP 01

Sketch out the face or trace the template on page 237.

STEP 02

Colour block the whole face and neck with a light beige marker pen.

STEP 03

Now for the clothes: take a dark blue marker pen and colour in the alternate stripes for the pattern of the top.

STEP 04

Now add the hair. I used a medium-brown marker pen here and circular pen strokes to create curly hair. Be careful going around the ear to avoid covering it completely.

STEP 05

Add some shadow to give the face dimension and shape. To do this, take a light blue marker pen and add a triangle shape under the chin, as I have here.

STEP 06

For the facial features, use all coloured pencils. Add two small dots for the eyes and two slanted lines for the eyebrows with a dark brown pencil. Then add the nose with a beige that is darker than the skin tone you used. For the smile, add a small, curved, red line!

You can add more texture to the hair. Taking a darker brown than the one used for the hair, add some curly marks to give it a little more dimension. Lastly, use black to draw in your character's spectacles.

Project 44

Figure 1

In this project we are going to draw a full figure, which means we can focus on the clothes as well as the face. I love adding busy patterns and popping colours to characters' clothes.

STEP 01

Sketch out the figure or trace the template on page 237.

FIGURE 1 199

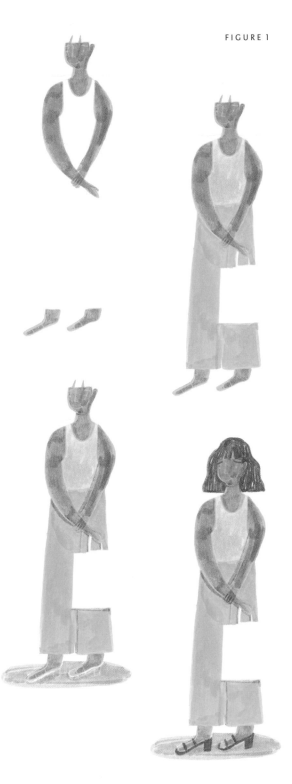

STEP 02

Colour in all the visible skin with a medium-brown marker pen. Be careful here to avoid going over any of the clothes as the colours we use next may not completely cover the skin.

STEP 03

Next, choose some fun bright colours for the vest top and trousers. I chose a lilac and coral marker pens for these.

STEP 04

Now you can add some shadows using a light blue marker pen. Do this where each arm crosses the body and where the bag is sitting over the legs. Add a thin line between the trouser legs to show that the light is coming from the right-hand side. You can also add an oval "puddle" beneath the figure to show the shadow she would be casting on the ground. This also stops her looking as if she is floating!

STEP 05

Now add the hair and sandals. Using a dark brown coloured pencil, add the sole and heel of the shoes and two straps going over the feet. For the hair, working from the top down, add wobbly lines all the way to the bottom.

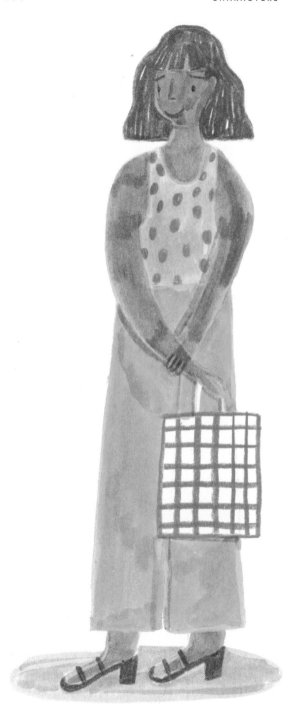

STEP 06

For the vest top, take a darker shade of lilac than the base colour and add some pretty polka dots all over! Then for the bag, take a bright red coloured pencil and decorate it with a grid pattern by drawing horizontal and vertical lines.

STEP 07

For the face, add two small dots for the eyes with a black coloured pencil. Then using the dark brown you used for the hair, add the eyebrows and the nose. Then take a dark red pencil and draw in the mouth with a small curved line.

FIGURE 1

Project 45

Figure 2

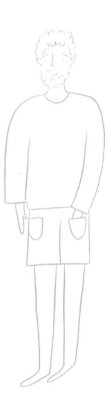

Here's another figure to draw with a summery feel to the wardrobe I've selected.

STEP 01

Sketch out the figure or trace the template on page 237.

FIGURE 2 203

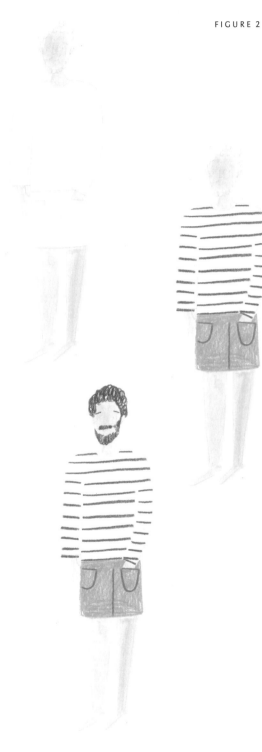

STEP 02

Colour in all the skin with a light pink marker pen. Be careful here and try not to go over any of the clothes, as the colours we use next may not cover the skin colour completely.

STEP 03

Next, choose some fun, vibrant coloured pencil for the top and shorts. I decided to use a bright blue to create a stripey top. Draw horizontal lines over the top, stopping at the arms and then starting again to show these are separate to the body. For the shorts, I used a bright pink and coloured them in gently, so they don't look like a solid colour. Then add some pocket details to the shorts with a bright pink marker pen.

STEP 04

For the hair, beard, moustache and eyebrows, colour them in using small, circular motions with a dark brown coloured pencil.

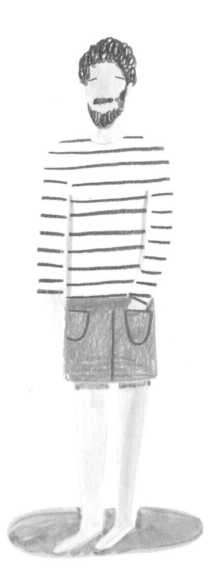

STEP 06

For the face, add two small dots for the eyes with a black coloured pencil. Use a beige pencil for the nose and two rosy cheeks. Then take a red colour and draw in the mouth.

Then, using the brown coloured pencil, add some leg hair by drawing small specks on the legs.

STEP 05

Next, take a light blue marker pen and add some shadows to the insides of the arms, the shorts where the top overhangs and also the legs at the bottom of the shorts.

FIGURE 2 205

Project 46

Summer outfit

This project involves drawing some fun summer clothes. Colourful clothing really adds personality to your character illustrations and it's one of my favourite parts.

STEP 01

Sketch out the elements for the outfit or trace the templates on page 238.

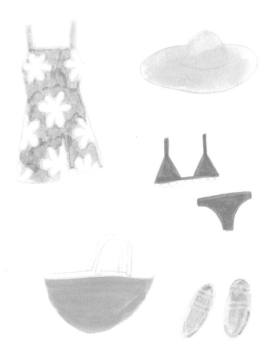

STEP 02

Colour in the main sections of all the elements. For the playsuit, I use a lilac marker pen and left the flowers blank at this stage. For the sunhat use a light beige marker pen. The bikini can be coloured in with a bright pink marker pen, leaving the frilly bit at the bottom blank. For the beach bag, use a coral-pink colour for the semi-circular shape, leaving the top edge and handles blank. Finally, for the sandals, take the same lilac colour you used for the playsuit and colour them in.

STEP 03

Next, start adding some details with coloured pencils. Add some little yellow dots to the centres of the flowers on the playsuit, using a bright coloured pencil. Then, on the sunhat use a beige that is slightly darker than the base colour and differentiate the top of the hat from the rim by drawing over the sketched lines. For the bikini, take a bright red and add the little frills by drawing a line of semi-circles. Then for the beach bag, colour in the front edge of the bag and the nearest handle in dark green and the furthest handle in light green. Finally for the sandals, take a darker purple and create an outline around the edge and add two horizontal lines across the tops to create the straps!

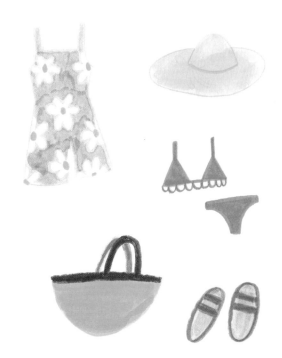

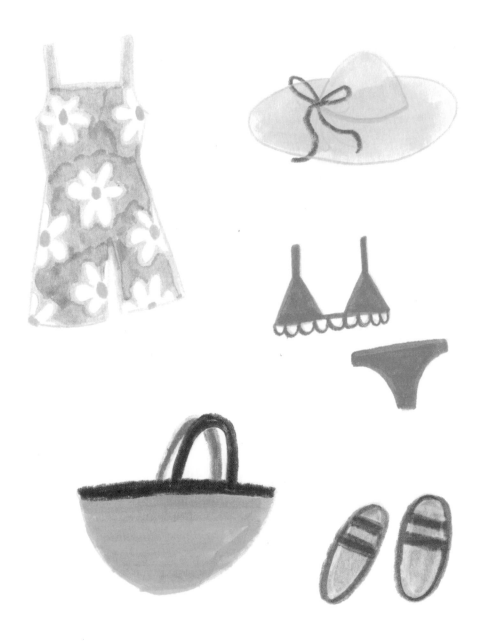

STEP 04

Finally, add a purple bow to the sunhat and some texture to the bag, using horizontal lines to make it look as though it's woven!

Project 47

Glasses

Adding accessories to an illustration of a person adds so much personality and makes them really come to life! This is perfect for finishing off a fun outfit or hairstyle.

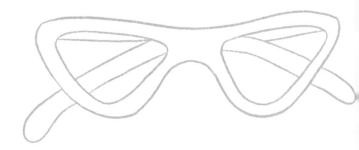

STEP 01

Sketch out the glasses or trace the template on page 239.

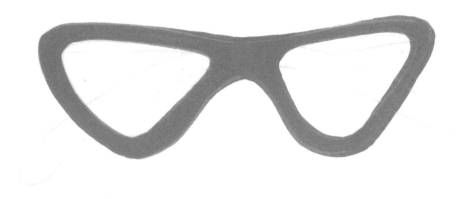

STEP 02

Use a nice bright pink marker pen to colour block the frame, leaving the arms blank for this step. Use a light pressure to ensure the lines are nice and neat when you go round the shape of the frame.

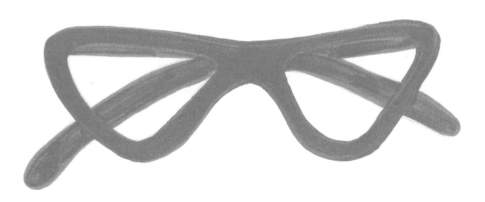

STEP 03

Then, taking a slightly different shade of pink, colour in the arms, being careful not to go over the main frame at the front too much.

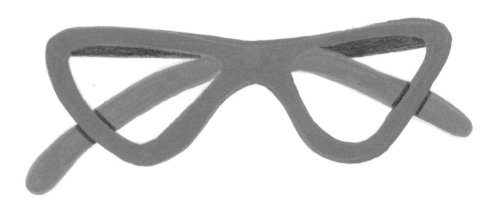

STEP 04

Then, taking a cool-toned coloured pencil that is darker than the pinks you've used, add some shadows to the parts of the arms that you can see through the lenses and where the frame crosses over the arms too. For the shadows, I used a lovely dark green pencil, but a blue would also work well.

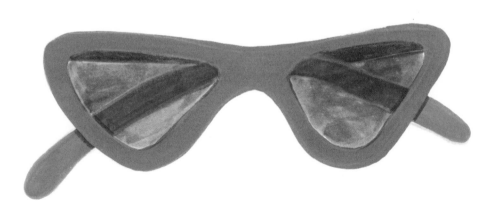

STEP 05

Finally, use a cool blue marker pen to colour in the lenses. The marker pen gives the impression of slightly coloured transparent glass.

Project 48

Boots

These boots were made for ... drawing! Here are a couple of fun pairs of boots to sketch out.

STEP 01

Sketch out the boots or trace the templates on page 238.

STEP 02

Take a pink marker pen and colour block all the ankle boots apart from the soles and heels.

For the cowboy boots, colour in the main shape with a lilac marker pen, but leave the soles, heel and inside of the boots blank.

STEP 03

Taking a dark pink marker pen, colour in the soles of the ankle boots. Use a very light pressure here, so you can get nice sharp lines and corners.

Use a magenta-coloured marker pen to colour in the inside of the cowboy boots. I used a darker colour for the insides so they look as if they are in shadow.

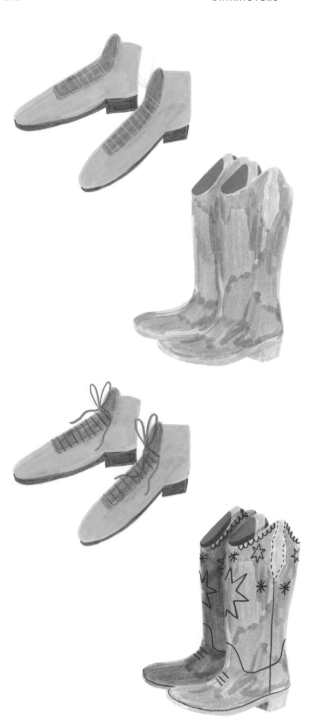

STEP 04

Now, using a light blue marker pen, colour in the tongues of the ankle boots, over the base pink colour. This helps the tongues look as if they are in shadow and not separate to the boots.

Next, add the soles, heel and tab details to the cowboy boots. I decided to use an apricot colour here as a lovely contrast to the purple.

STEP 05

Finally, take a bright red coloured pencil and draw in the laces and bows on the ankle boots. To do this, draw short horizontal lines over the tongues of the boots and then two upside-down teardrop shapes at the top of the laces for the bows. Don't forget to add the ends of the bows.

For the little details on the cowboy boots, use a dark blue coloured pencil. Make sure the pencil is sharp, so you can get nice fine lines for these. For my cowboy boots, I decided to add stars and some little frilly patterns at the tops using small semi-circles.

Project 49

Hairstyles

Hairstyles are a key way of expressing your characters' personalities. They're also a fab way to experiment and have fun with the people you're illustrating.

STEP 01

Sketch out the head and shoulders of your characters, or trace them from the templates on page 238–239.

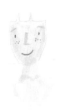

STEP 02

Next, taking a range of different coloured marker pens for the skin, block colour the faces. Leave the hair blank at this point.

For each face, use sharp coloured pencils. Add two small black dots for the eyes and make them level with the ears.

For the eyebrows, add two small, slanted lines above the eyes and then draw in a nose for each character. Give the girl with ginger hair some freckles too.

Finally, add a smile to each face with a bright red pencil.

STEP 03

Now for the hair! There are no real rules here, but make sure you add some texture to each one. You could start with a marker pen for the base colour of the ginger and black hairstyles and then add texture with a pencil. For the red and brown hair, you could stick with coloured pencil and use a scribbling motion to give it movement and texture.

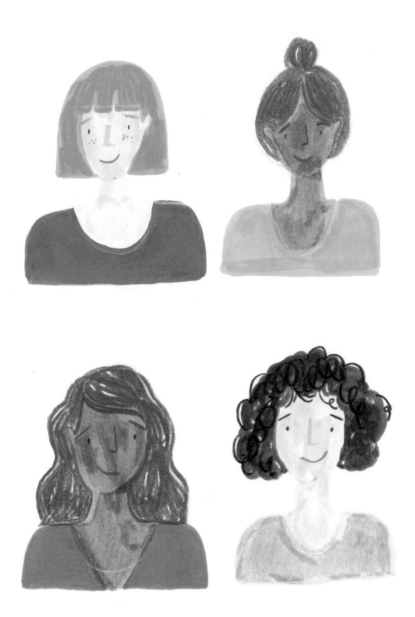

STEP 04

Now finish off your characters with some colourful clothing. Use some lovely vibrant marker pens to colour the base of the outfits and then add any details with coloured pencil over the top.

Project 50

Winter outfit

For this project we're going to draw some cosy winter clothes. Use these to bundle up your characters and keep them toasty and warm!

STEP 01

Sketch the winter outfit or trace the template on page 239.

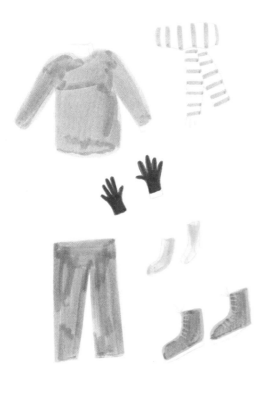

STEP 02

First, lay down the base colour for all the items using marker pens. For the scarf, I chose an olive green and made it stripey by drawing vertical lines on the top section and horizontal lines on the bottom sections. This helps to show that the two sections are separate and lying in different directions.

For everything else, I used a block colour. Either copy the colours I used here or try using your favourite jumper or trousers as inspiration.

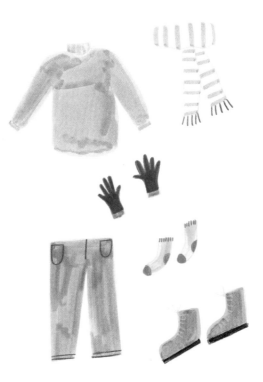

STEP 03

Next, colour the sections that you left blank, so the cuffs and collar of the jumper, the soles of the boots and the cuffs of the gloves. Also add any details to the jeans and the tassels to the ends of the scarf. I chose a darker shade of green coloured pencil for the tassels. Use a red coloured pencil for the toe and heel sections of the socks. I chose red because I love how pink and red look together.

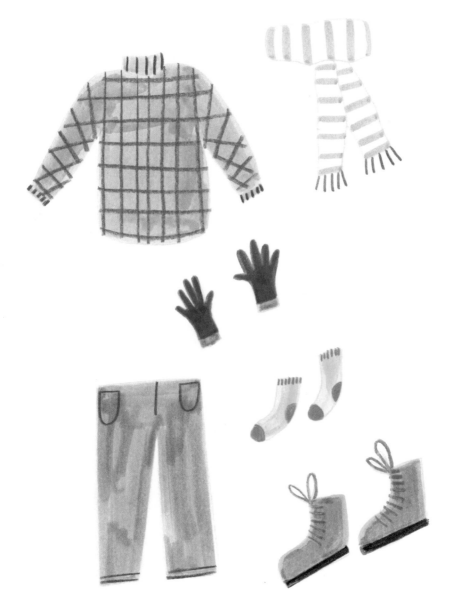

STEP 04

Finally, add all the little details that really finish off each piece of clothing. I used a dark brown coloured pencil (darker than the shade of brown of the boots) to add some laces. For the jumper, I used a dark teal coloured pencil to add a grid pattern to the body. To do this, draw all the horizontal lines first and then add vertical lines over the top – don't forget to add some matching lines to the collar and cuffs!